PORTALS & GATES

9 . 4 . 04

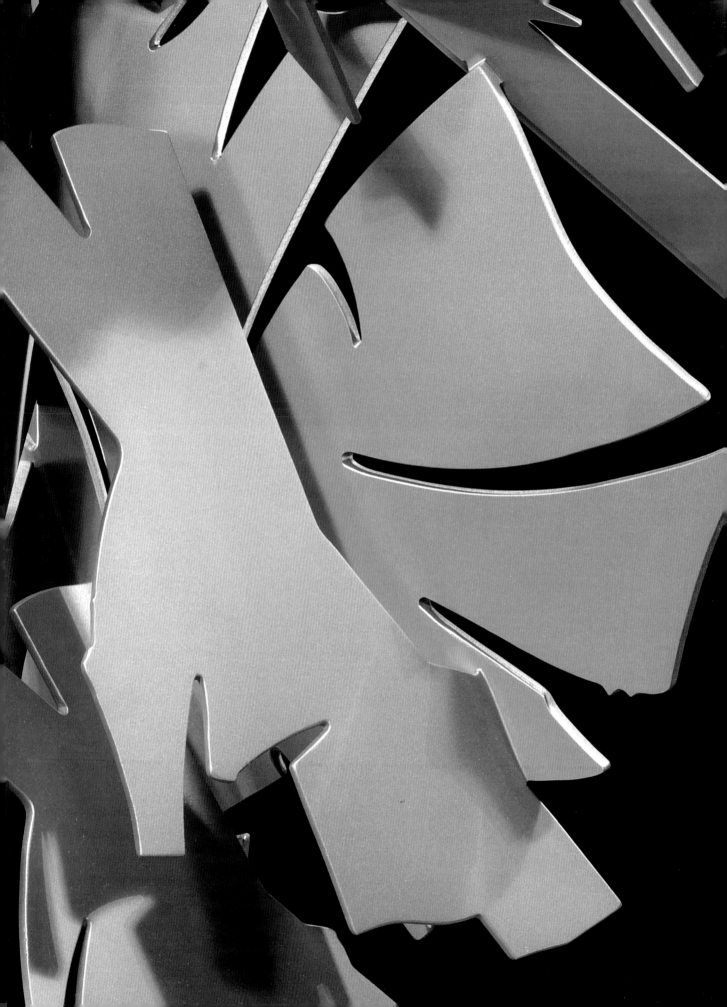

ALBERT PALEY | PORTALS & GATES

M. JESSICA ROWE

with forward & essays by

LYNETTE L. POHLMAN

GREGORY L. GEOFFROY

WILLIAM L. CLARK

MARK C. ENGELBRECHT

CHRISTIAN PETERSEN ART MUSEUM

BRUNNIER ART MUSEUM

UNIVERSITY MUSEUMS, IOWA STATE UNIVERSITY, AMES, IOWA

HOMETOWN PERRY, IOWA

Front and back cover:
(detail) Albert Paley, **Transformation**, 2007

Endpapers: (detail) Installation
of **Sentinel**, 2003
Formed and fabricated Cor-Ten and
stainless steel and bronze
73 x 30 (diam.) feet (22.25 x 9.14 m)
Rochester Institute of Technology,
Rochester, New York
Paley Studio Archive, SF 2003.01

pp. 2–3: **Proposal Study for
Memphis Portal**, 2004
Red pencil on paper
23 x 30.5 inches (58.4 x 77.5 cm)
Paley Studio Archive, GA 2004.01

p. 4: Detail of **Interlace**, 2005
Formed and fabricated mild steel
and polychrome finish
Paley Studio Archive, SF 2005.05

LENDERS TO

Albert Paley | Portals & Gates exhibition and publication

The Renwick Gallery, Smithsonian Institution

Howard and Roberta Green Ahmanson

Albert Paley

Anonymous private collectors

CONTRIBUTORS TO

Albert Paley | Portals & Gates exhibition and publication

Hometown Perry, Iowa

The Henry Luce Foundation, Inc.

University Museums, Iowa State University

University Museums Membership

Arthur Klein

Ann and Al Jennings

CONTRIBUTORS TO

Transformation (2007) by Albert Paley

Class of 1956, Iowa State University

Iowa Art in State Buildings Project for Morrill Hall

University Museums, Iowa State University

Rebecca Klemm

Martha LeBuhn Allen

National Endowment for the Arts

Ruth and Clayton Swenson

CONTENTS

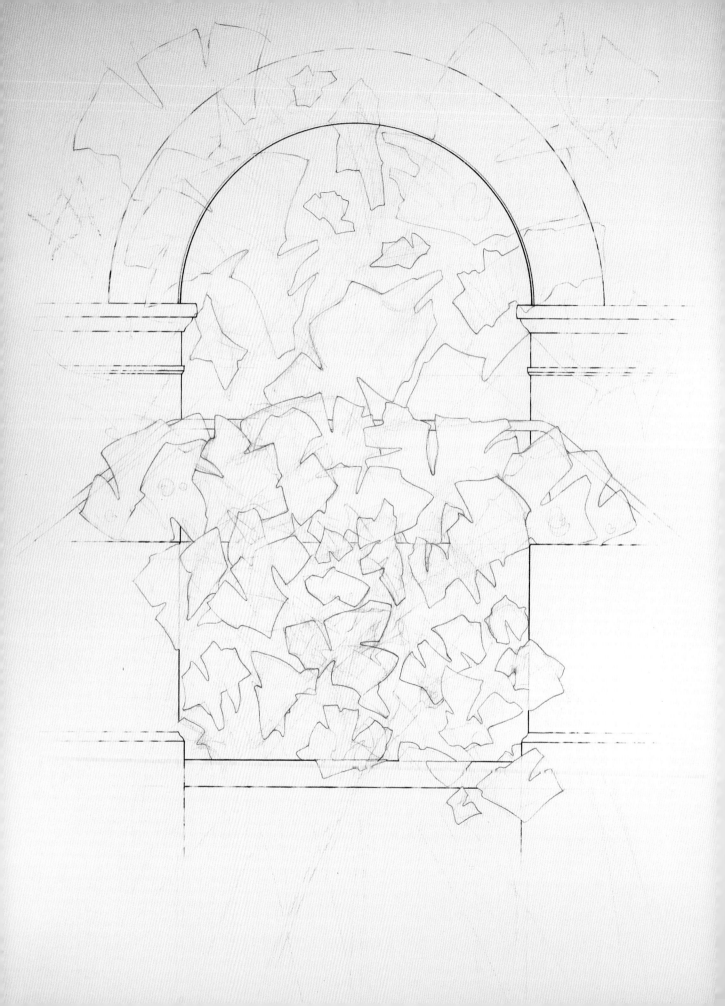

FOREWORD

GREGORY L. GEOFFROY President, Iowa State University

When Morrill Hall was constructed in 1891, it immediately became the center of the institution. Over its entry were inscribed, in stone, the words "Chapel," "Library," and "Museum" as these were the three principal purposes the building fulfilled, and students passed through Morrill Hall every day for their academic studies and as part of their personal lives.

Gradually that changed. The library was moved to a new library building in 1925. Attendance at chapel, which was required of students not only on Sundays but on weekday evenings, was phased out, with daily chapel attendance discontinued during World War I and Sunday chapel discontinued with the retirement of the college chaplain O.H. Cessna in 1929. And the collections contained in the college's natural history museum, which included examples of both native and exotic animals, such as a stuffed camel, have long since been relocated to other places or discarded. Even the vocal music students and faculty stopped passing through Morrill Hall when the Music Building was constructed, and they no longer needed the former chapel/auditorium for their rehearsals. For the next eighteen years, Morrill Hall housed only administrative staff, and, in 1998, it was closed due to disrepair.

Fortunately, that closing was not the final chapter in the Morrill Hall story. Thanks to the wonderful generosity of the alumni, friends, faculty, staff, and students of Iowa State, we are writing a new chapter in the Morrill Hall story, one that returns this magnificent and historic structure to the central role it played in the life of the institution and its students for many decades. Once again, students will pass through Morrill Hall as a part of their daily academic and personal lives, and their experiences inside will be enriched by a structure that has been beautifully restored and renovated, and by collections and programs that enhance the entire learning environment at Iowa State.

The entrance to Morrill Hall is still highly symbolic. Students entering will still see the words "Chapel," "Library," "Museum" inscribed in stone over the entrance, but they will now also see and experience the dramatic artwork of Albert Paley as they enter.

Mr. Paley was commissioned to create the art for Morrill Hall through Iowa's Art in State Buildings Program because his work captures the essence of the transformational experience students have when they go to college — passing through its many buildings and programs and absorbing what they have to offer — and because of the complimentary nature of his work to that of Iowa State's famed artist-in-residence of twenty-one years, sculptor Christian Petersen. Petersen's dedication to Iowa State helped transform our campus into an artistic treasure, and restoring Morrill Hall provides us with a suitable place to display many of his sculptures for people to experience and enjoy every day.

Morrill Hall, with its Christian Petersen Art Museum, Museum for Visual Learning in Textiles and Clothing, and Center for Excellence in Learning and Teaching, has been restored to its place of honor on the historic Iowa State University campus and transformed into a modern learning laboratory for the students and faculty of today and tomorrow. Thanks to Mr. Paley, we will be able to fully appreciate this significance every time we enter Morrill Hall under the words "Chapel," "Library," and "Museum."

opposite: **Iowa State University Project Proposal,** 2005
Red pencil on paper
30.25 x 23 inches (76.84 x 58.42 cm)
Paley Studio Archive, SCU 2005.01.01

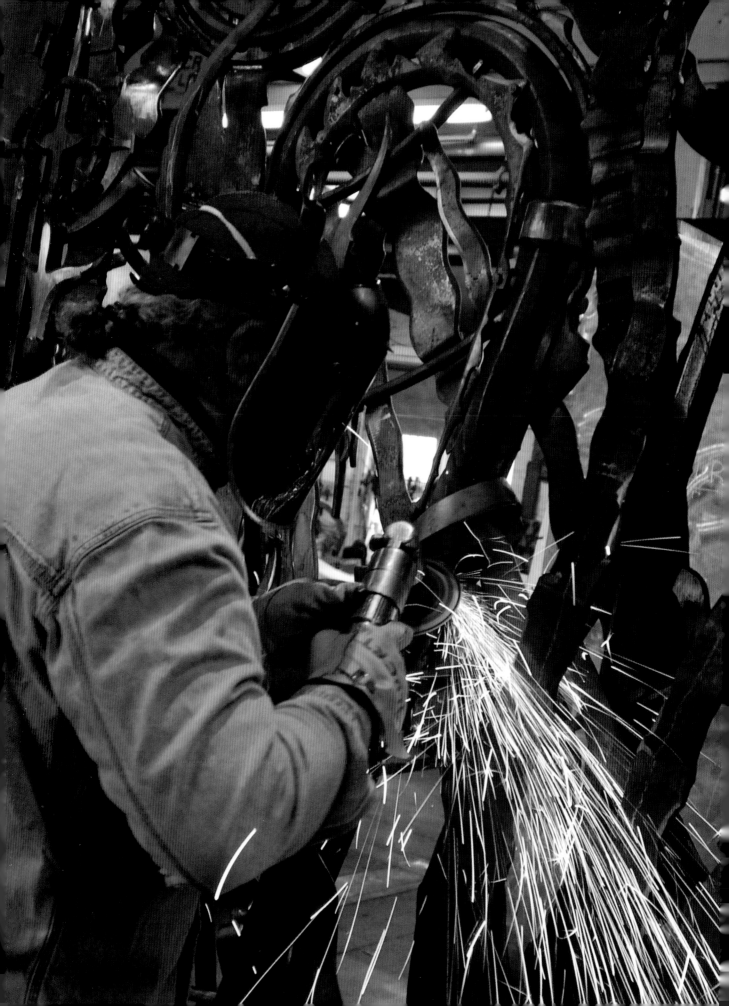

THE ACT OF PASSAGE | FROM PETERSEN TO PALEY

LYNETTE L. POHLMAN Director and Chief Curator, University Museums, Iowa State University

The act of passage for a campus community can mean many things: the passage from secondary to higher education, the passage of knowledge from professor to student, the passage from college life to the real world, and the passage from student to teacher. Rituals and rites are associated with these passages during a student's college career: freshman orientation, a change in social scenes, metamorphosis in a field of study, and obtaining degrees and recognition. These acts of passage are place holders in our memory that we can call upon to remember where we have been and where we plan to go.

In 1934, sculptor Christian Petersen became the nation's first campus artist-in-residence. He was hired by Iowa State College President Raymond M. Hughes at the depths of the greatest economic struggle in American history. Hughes put his faith and trust in Petersen, believing art should be integrated into campus life at Iowa State, especially for the practically focused engineering and agriculture students. At this pivotal moment in his career, Petersen probably yearned to create a powerful and lasting impact on campus with his sculpture, but even he did not realize how successful he would be. His art endures at Iowa State as each student experiences his sculptures, and his teaching legacy is ensured by the memories of his students, faculty colleagues and community friends.

By the time Petersen retired in 1955, he had created twelve major public works of art, such as The History of Dairying Mural, Fountain of the Four Seasons, The Veterinary Medicine Mural with The Gentle Doctor, and The Wedding Ring — all important campus icons. He also created hundreds of studio sculptures and thousands of drawings, many of which are now in the permanent Christian Petersen Art Collection. Most importantly, both Petersen and

Hughes initiated the foundation for what we now call the Art on Campus Collection.

In March 2007, we inaugurated the Christian Petersen Art Museum at Morrill Hall in honor of Christian Petersen's artistic and teaching legacy at Iowa State. The Christian Petersen Art Museum is home to the Christian Petersen Art Collection, the Art on Campus Collection and Program, the Visual Literacy and Learning Program, and the Contemporary Changing Exhibition Program.

Since Petersen's day, other great artists have painted, sculpted, cast, and created works of art for the Iowa State campus. Today Iowa State has the nation's largest campus public art collection with over six hundred major public works of art by nationally and internationally renowned artists. These public artists have worked with more than a thousand members of Iowa State's faculty, staff, and students to develop, create, and enhance our collecting and educational mission. This unprecedented public art collection is also due to the continued campus collaborations of artists, the Iowa State community, and the many friends of the University Museums.

This long-standing tradition of public art excellence continues with the addition of Albert Paley's work of art to the entrance of Morrill Hall. Paley's sculpture, Transformation, is a contemporary portal of exquisite beauty, laced with meaning. Paley's distinct sculpture represents the intrinsic response to beauty and art for an ever-evolving academic campus community where acts of passage are a daily ritual.

Paley's installation codifies the main entrance of Morrill Hall as a gateway to learning through arts and sciences. The sculpture welcomes and inspires faculty, staff, students, public school groups, and visitors throughout the nation and encourages them to further

p. 10: The artist Albert Paley forging and
fabricating *Design Study for the Good Shepherd Gate
at the National Cathedral*, 2007

opposite: **Iowa State University Project Proposal**
(drawing for *Transformation*), 2005
Paley Studio Archive, SCU 2005.01.01

explore the educational entities contained within
the building and the campus. *Transformation* also
exemplifies the architectural transformation of
Morrill Hall from the 1891 historic building to a
contemporary center of campus learning.

The similarities between Petersen and Paley are
remarkable. Each began his career as fine jewelry
makers who aspired and worked to become fine art
sculptors. Petersen and Paley created major public
works of art and also became campus artists and
faculty members at universities focused on technology.
It is fitting that Paley's contemporary sculpture be
situated at the entrance to a museum dedicated
to the artistic legacy Petersen began by accepting his
campus artist-in-residency position in 1934.

ACKNOWLEDGEMENTS

As in any major undertaking, there are many people
who make these special projects a success. I deeply
thank M. Jessica Rowe for her diligence in visioning,
directing, and authoring this publication, for her
extensive and thorough work on the exhibition
Albert Paley | Portals & Gates, and for her prowess
as a researcher and curator of contemporary art.

Thank you to the lenders to the exhibition:
The Renwick Gallery, Smithsonian Institution;
Howard and Roberta Green Ahmanson; anonymous
private collectors; and most significantly, Albert Paley.
My sincere appreciation to those who have also
contributed essays to this publication: Iowa State
University President Gregory L. Geoffroy; William
Clark, president, Hometown Perry, Iowa; and, Iowa
State University's College of Design Dean, Mark
Engelbrecht. I would also like to thank Connie Wilson
for her exceptional graphic design for this book,
Ken Burditt for coordinating the publication process,

and Lea Rosson DeLong for editing the publication.
Once again the University Museums staff was key in
the realization of these projects. Though often playing
a behind-the-scenes role, their momentum and
ingenuity remain steadfast. The staff includes:
Amanda Hall, Janet McMahon, Jennifer Ohlerking,
Sue Olson, Eleanor Ostendorf and Allison Sheridan.

I am deeply thankful to Albert Paley for all his
efforts and collaborations in creating *Transformation*
for Iowa State's Art on Campus Collection and for
making many, many resources available to Iowa
State's University Museums to organize this exhibition
and publish this important book to document his
legacy of art focusing on his portals, gates, and the
acts of passage. Paley Studios has a wonderful and
collaborative team, and I especially wish to
acknowledge David Burdett and Elizabeth Cameron.
Bruce Miller has photographed Albert Paley's art for
over three decades, and his photography is a dynamic
addition to this book. Paley Studios contributed time
and professional expertise, art loans, archival
searches, photographs, and patience, and their
collaboration has been pivotal to the creation of this
book and exhibition. Thank you to the Art in State
Buildings Committee for Morrill Hall who selected
and awarded the public art commission to Albert
Paley; they include: Kathleen Baumgarn, Corly Brooke,
J. R. Campbell, Mark Chidister, Kerry Dixon-Fox,
Mary Gregoire, Jane Henning, Scott Sankey and
Susan Yager. Special thanks to RDG Planning and
Design of Des Moines, especially Scott Sankey, Scott
Allen, and Kevin Nordmeyer for their collaborative
efforts in working with Albert Paley and the University
Museums on this public art project, and to ISU
Facilities Planning and Management for their
coordinating efforts. Most especially to Howard and

Roberta Green Ahmanson, I am deeply grateful for their continued support of University Museums and for fostering University Museums' partnership with Albert Paley and Hometown Perry, Iowa.

Art is eternal, funding is not — I am especially appreciative of those individuals and institutions that have funded and supported both the exhibition and the public art sculpture, *Transformation,* at Morrill Hall. For major funding support as well as being an exhibition partner in conjunction with *Albert Paley | Portals & Gates,* I am especially grateful to Hometown Perry, Iowa. Providing support for discovery and education of American art, The Henry Luce Foundation, Inc. contributed significant financial support for this exhibition, publication, and educational programming. And to Arthur Klein, Ann and Al Jennings, and the University Museums' membership, I express our appreciation for their decades of continuing exhibition support to the University Museums and for supporting this important project. To Rebecca Klemm, Martha LeBuhn Allen, and the ISU Class of 1956 we offer our sincere thanks for generously supporting the acquisition of Albert Paley's sculpture *Transformation*, which is also supported in part by an award from the National Endowment for the Arts, and by the Iowa Art in State Buildings Program.

Finally, I would also like to express my sincere appreciation to those who came before us who have conceived, molded, persevered, and sustained the arts on campus and their educational vision to serve Iowa State University.

A GLIMPSE OF THE ETERNAL

Just now,

a sparrow lighted

on a pine bough

right outside

my bedroom window

and a puff

of yellow pollen

flew away.

A Glimpse of the Eternal, by U.S. Poet Laureate Ted Kooser, is from *Delights & Shadows*, Copper Canyon Press, 2004, and is reprinted by permission of the author. This poem was selected by Kooser for *Transformation* (2007).

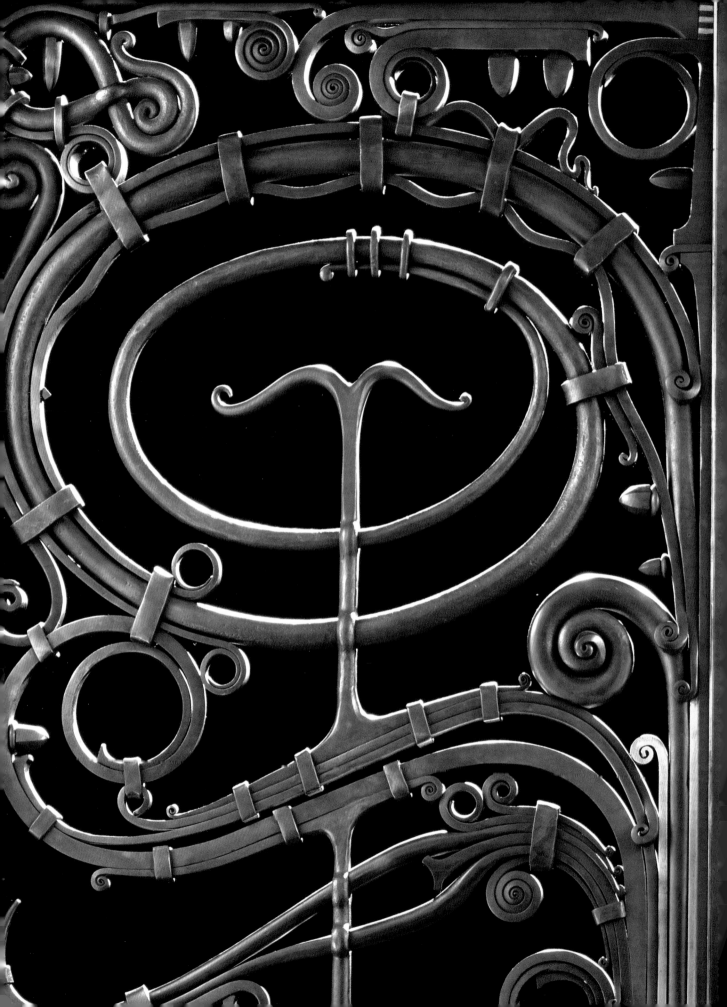

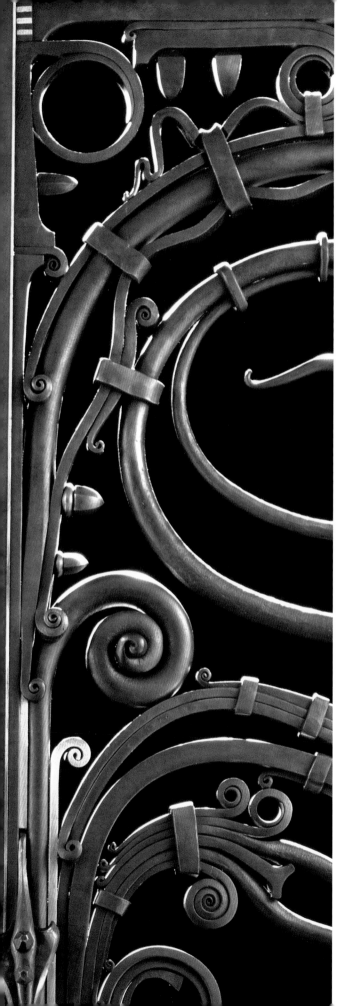

PORTALS & GATES

M. JESSICA ROWE Guest Curator, University Museums

Embodying artistic traditions of teamwork to unparalleled extents, Albert Paley's works of art celebrate both the triumph of technology and the splendor of our natural world. Whether integrated into public architectural settings or reserved for private places, his sculptures express the acts of going, growing, changing, and the processing of time. Their function is aesthetic, symbolic and utilitarian — all simultaneously.

The premise of "passage" to which Paley draws us is, more often than not, symbolic. His emblematic, site-specific gates and portals offer a means of access to the mysterious. His aim is to give expression to his inner vision of passage, not only in the realm of the concrete world, but also in that of the individual and nature. These objects convey a dynamic psychological quality, for they indicate a threshold and invite us to move across it.

SYMBOLS OF PASSAGE

Symbols of passage imply the transcending of the limitations of the rational mind: a pathway, corridor, doorway, gateway, opening, journey, or crossing. The notion of passage, a situation often associated with a heroic struggle, is based on an initial separation, followed by transition, to a final state of unity. A hero's journey is elucidated by Joseph Campbell in his well-known book, *The Hero with a Thousand Faces*, in which he defines its basic course as follows: "The standard path of the mythological adventure of the hero is a magnification of the formula represented in the rites of passage: separation — initiation — return."[1] Using this recipe of passage, separation blends the allure of adventure, the crossing of the threshold, and the entrance into an inner domain. Initiation implies a sequence of tests culminating in the conveyance of a gift or approval. Return consists of transformation, the crossing of the return threshold and the presentation of the gift gained to a waiting

A mighty flame followeth a tiny spark.

DANTE ALIGHIERI (Italian, 1265 – 1321)

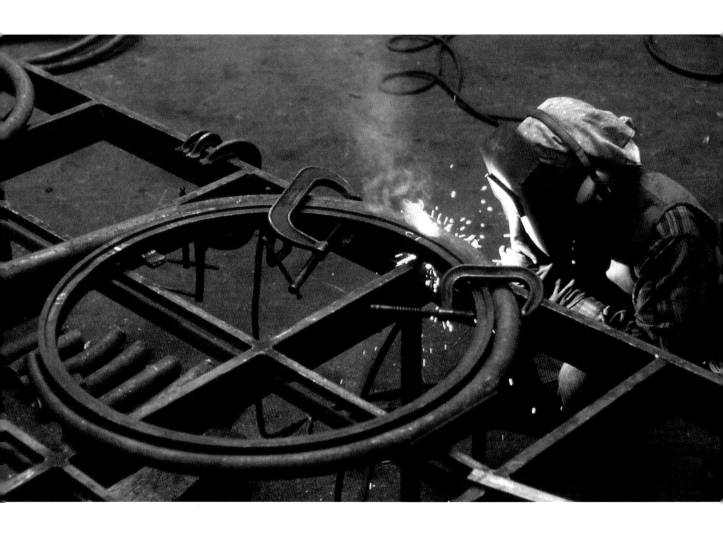

fig. 1, pp. 14–15: Detail of **Portal Gates,** 1974
Forged and fabricated mild steel, brass, bronze, copper
90.25 x 72 x 4 inches (229.2 x 182.9 x 10.2 cm)
Signed middle vertical "1974 Albert Paley"
Smithsonian American Art Museum, Washington, D.C.,
Commissioned for the Renwick Gallery, 1975.117.1a-b
Paley Studio Archive, AG 1974.01

fig. 2, Paley works on production of
Albany Senate **Portal Gates** (1980)
at 1237 East Main Street, Rochester, New York.
Photo credit: William Rowley

community. The oeuvre of Paley's more than forty major commissioned projects — doorways in cathedrals, gates to gardens, portals into government chambers, entrances of museums, and ceremonial crossings at universities — are both the affirmation and fulfillment of this theme of passage.

EARLY WORK

Venturesome statements illustrated in massive jewelry — cast, pierced, carved, forged in precious metals, and embellished with gemstones — dominated his work during America's cultural revolution of the 1960s. With a practiced command of surface ornamentation and an organic approach to sculptural design, Paley's bracelets, fibulas, pendants, pins, and rings set about to dismantle limiting, defining frameworks of this art form. Around 1969, his work began to evolve beyond bodily adornment, as he fashioned and integrated hand-wrought metalwork into built surroundings. Yet, there are similarities between his two disciplines, as Paley explained. "The basic problem of decorating a human form or decorating an architectural space is the same. Only the scale is different."[2]

1969 is the year Paley earned a Master of Fine Arts degree at Philadelphia's Tyler School of Art and was then recruited to the Rochester Institute of Technology in upstate New York where he taught goldsmithing for three years. His teaching career included a professorship at the State University of New York in Brockport (1972–84) before he returned to RIT to accept the Charlotte Fredericks Mowris Endowed Chair in the College of Imaging Arts and Sciences in 1984. The decade of the seventies cemented his standing as a leader in the nation's craft revival and produced a bounty of national and international honors, including a Fulbright Fellowship.

One practical result of this magnitude of attention was the 1984 establishment of his studio foundry in Rochester, New York. Today, Paley Studios Ltd. has a team of professionals and skilled technicians who, with subcontractors, collaborate with the artist on large-scale projects in a variety of metalworking disciplines.

Beginning with his commission in 1972 for the Renwick Gallery of the Smithsonian Institution in Washington, D.C., Paley's distinctive gateways have drawn the viewer into an inner domain using the subject of passage while the objects themselves possess added content through formal and associative elements. Along with the Renwick gates (finished in 1974), two other seminal works of art launched this theme: *Portal Gates* of 1980 for the New York State Senate chambers in the state capitol at Albany and the *Victoria and Albert Gates* for London's Victoria and Albert Museum in 1982. The legendary Renwick *Portal Gates*, a centerpiece for that building, is visually mesmerizing in its *tour de force* construction. Using forged and hand-hammered steel, brass, copper, and bronze, *Portal Gates* [*fig.1*] is a perfectly proportioned grid on long, slender metal rods assembled into a stalk-like cluster. As with natural vines, this metal variety appears to twine and climb by elongating its stems and attaching itself to whatever support is available. The composition Paley created for the Renwick *Portal Gates* simulates the natural phenomenon of thigmotropism (plant growth reacting to surface contact) with the profusion of climbing metal tendrils that seem to have responded to the artist's "touch" in the forging process. The Renwick gates mark the defining crossroads when Paley's virtuoso craftsmanship morphed in scale from *avant-garde* goldsmithing to large-scale blacksmithing. This breakthrough commission was an immediate success

and provided the first opportunity for Paley to combine large-scale ironwork with architecture. As prestigious commissions from across America and around the globe came to Paley, his innovative approach to the idea of passage continued to develop.

His second major commission, also called *Portal Gates*, [*fig.4*] was created in 1980 for interior thresholds of the architecturally unique state capitol of New York in Albany. Three distinct proposal drawings were developed by the artist in 1978 from which the most symmetric design was selected. The project was realized with two sets of open framework gates whose scale (more than thirteen feet high) befitted the architecture of the existing building's blend of Renaissance and Romanesque revival styles.

Paley designed Albany's *Portal Gates* "to enhance the architecture, to symbolize the rites of passage, and to speak in a spiritual sense of the formality and dignity of government."[3] Gradually tapered steel, brass, and bronze reeds echo the ribbed vaults in these historic senate chambers. While closed, the utilitarian function of the gates is protective. In the closed position, they reveal Paley's studied aesthetic with choreographed bands of parallel metal rods that suggest the curve of a ram's horn or the glyph of a ram. Ram horns also represent a sprouting seed, signifying potential or an upward flow of spirit. As Paley's design moves upward, then outward, and finally downward, it suggests ultimate sacrifice. The gates' crest ornament [*fig.3*] is a luminous gold abstraction that can be read as a cranial form (the skull of a ram), symbolizing the common phrase of "ruling with one's head." Each double gate swings open from a central "stem" of sprouting, willowy spires — conceivably an encouragement to "spur" the Senate on toward diligent efforts and constructive ends.

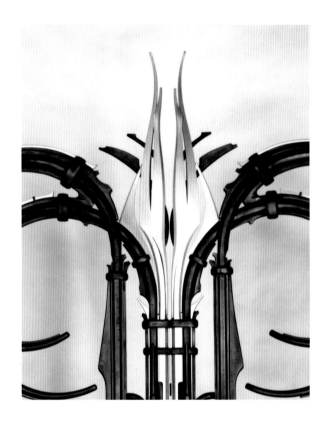

The *Victoria and Albert Gate* (1982) [*fig.5*] was created for the Victoria and Albert Museum's 1983 traveling exhibition, "Towards a New Iron Age." A masterpiece of forging, its steel form was meticulously manipulated by stretching, compressing, twisting, and cutting the hot metal. The apparent spontaneity and ease of handling this metal belie the great effort that went into activating the finished surface. Steel edges were 'chamfered' — cut, not beveled. Techniques to connect movable sections of the *Gate* included "drifting"— that is, spreading the hot metal by cutting holes with tapered punches to create natural swelling shapes. The *Victoria and Albert Gate* is a demonstration piece of Paley's bravura style. In a review of the exhibition, American architect and author

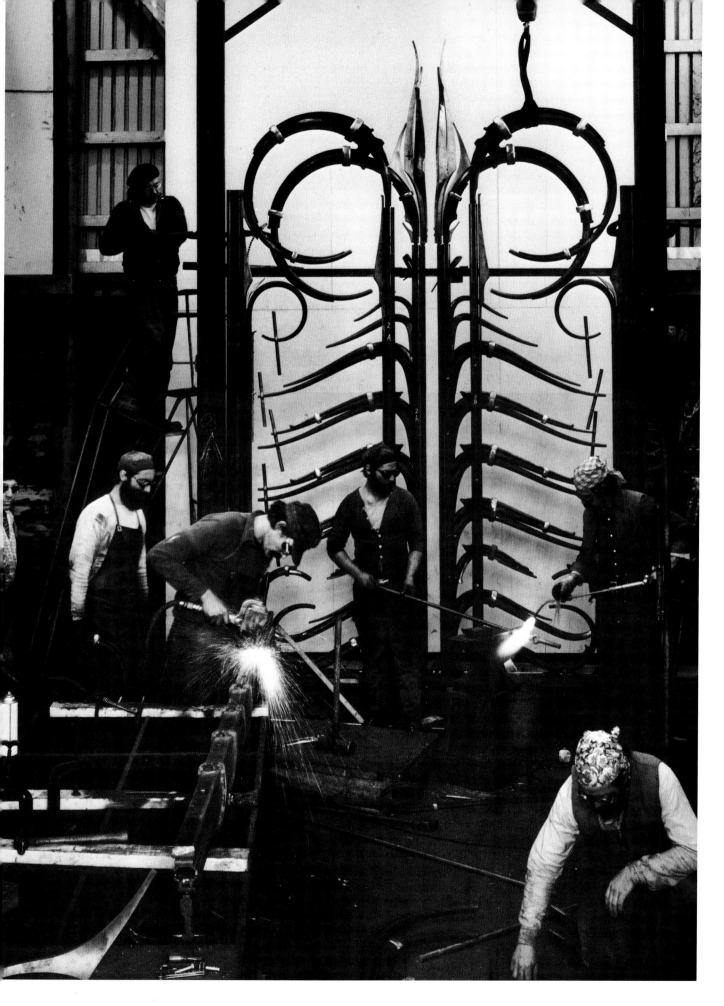

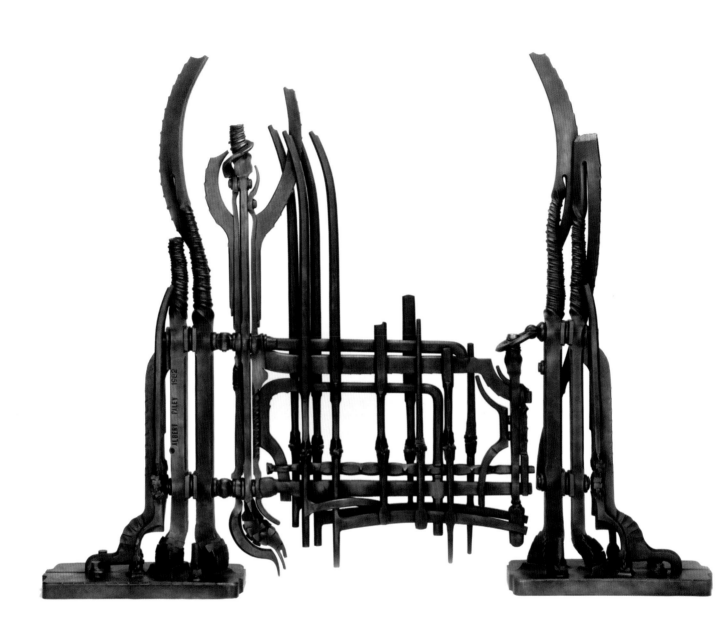

fig. 5, **Victoria and Albert Gate,** 1982
Forged and fabricated mild steel
with black patina
Signed, stamped "Albert Paley 1982"
82.5 x 106.5 x 13.5 inches (with base)
(209.6 x 270.5 x 34.3 cm)
Paley Studio Archive, AG 1982.01

Joseph Giovannini wrote that Paley's compelling gates and fences make "the best case for the return of ironwork pieces conceived for buildings.... Mr. Paley produces very strong work that we want for our buildings not because it is useful but because it is extraordinary. Its art, rather than function, is its justification."[4]

NATURE

From the outset of his career, Paley has turned to nature not only for the materials of his art — metals — but also for design motifs, and his oeuvre is filled with all manner of flora and fauna. Nature's bounty has plenty to offer, especially to an artist as ebullient and innovative as Albert Paley. The unexpectedly sensuous quality of metal is emphasized in his hands by designs which defy its hard, resilient character by molding, bending, and twisting, as though it were an elastic substance.

Paley has honed his aesthetic from nature's formal beauty and exuberant ornamentation in part from study experiences while in Europe and also from interests in horticulture and in the nineteenth century style, Art Nouveau. He has amassed a collection of Art Nouveau decorative art with Frances Paley, his wife and fellow artist. The collection figures prominently in their home along with natural treasures such as a Bighorn sheep skull, contorted branches from Corkscrew Willow trees, giant pink Murex conch shells, and bouquets of hydrangea flower-heads. Edward Lucie-Smith tells us, "The metaphor of swarming vegetation alchemically transformed"[5] is his signature in forged metal objects.

Paley said in 1983, "The shape comes about because when the iron is hot, it has a great deal of natural movement. It just flows into curves, and when it's cooled, the motion is frozen. I find the Art Nouveau shapes very seductive. When I first studied design, I had Bauhaus teachers. At first, when I realized I was a romantic, I was sort of shocked and shamed. But it is true...that the material I work most with is emotion."

The contradiction of strong, rigid metals and sensitive, fine forms inspires Paley. Just as a garden is created by establishing an ecosystem comprised of grasses, plants, shrubs, and trees native to its geography, so also Paley constructs imaginary compositions of abundance and diversity. "They are in fact the embodiments of the sensuous wonderland that the garden symbolizes."[6]

PROCESS AND DESIGN

In contrast to the Renwick and Albany projects — both commissioned for historic structures — the *Pedestrian Gate* (1985) for the Virginia Museum of Fine Arts in Richmond was Paley's first commission for a new building. As in earlier projects, collaboration was an important aspect of his work. This collaborative process engages the artist from the first contact through the negotiations characteristic in balancing artistic desires with the mandates of each commission. Receptive communication is a critical ingredient to his success. He is conversant with issues involved in site selection and the ideas operative within each site and in the creative process, fabrication, and installation of the work as well. "When I'm forming the concept, my prime consideration is its relationship to architectural space," the artist reported in an interview.[7] For Paley, challenges lead to solutions with each new project. He begins by making quick, fluid, conceptual sketches; delicate ghost-like presences materialize from smudged or reworked graphite marks. The experience of drawing offers Paley an unencumbered means of

quick improvisation. The arabesque, spiraling rhythms seen in Paley's early interpretations of the *Portal Gates* of the Renwick Gallery run through illustrations in his present-day journal entries. One example in particular, his *Sketches for the Tabernacle Screen, Temple Israel, Dayton, Ohio* (1993), demonstrates the role of drawing in his process to image. From earliest concepts to final image, this series shows his multiple ways of extracting the essence of drawing's built-in economy and performance.

By drawing, he can react to new forms around him, distill form from memory, invent new form, and plan complicated relationships. For instance, the pencil drawings of the *Fischer Gates* (1989) and *Linde Interior Gates* (1990) [*fig.6*] helped to refine the artist's thoughts in a direct way. Similarly, multiple drawing versions helped to plan the *Ceremonial Portal* (1991) at Arizona State University and the Florida State University *Stadium Entrance* (1999). Occasionally, graphic concepts that began in one project, but that were not used in the final object,

re-emerge in other projects. For example, the delicate membrane-like lines of early drawings for the *Central Park Zoo Gate* (ca. 1983) [*fig.12*] were later extracted for the bold archway called *Animals Always* for the St. Louis Zoological Park.

Paley explained the significance of drawing in the collaborative process. "The drawings enable me to experience and completely understand form before going into metal and to explain the form to somebody else. After that communication is understood, I go into the studio."[8] As the design process moves ahead, each successive drawing becomes increasingly precise as the design is translated into refined patterns,

fig.6, upper, left to right: **Linde Gates**, 1990
Ink on vellum
each: 8.5 x 11 inches (21.6 x 27.9 cm)
Paley Studio Archive: GA 1990.02;
GA 1990.03; GA 1990.04; GA 1990.05

fig.7, opposite: **Door Handle Proposal**, 1991
Red pencil on paper
13 x 9.8 inches (33.02 x 20.08 cm)
Paley Studio Archive, AO 1991.06

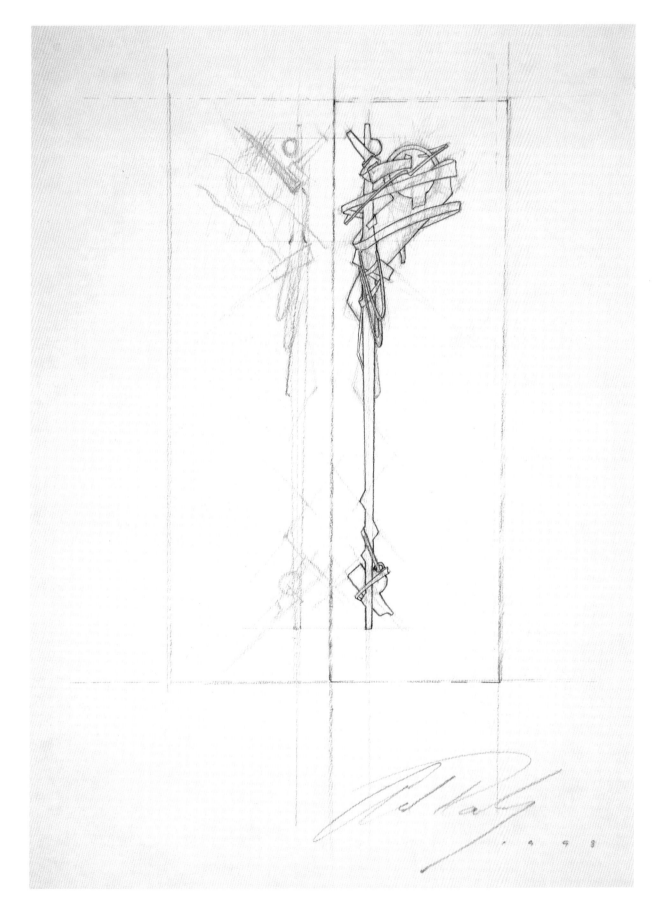

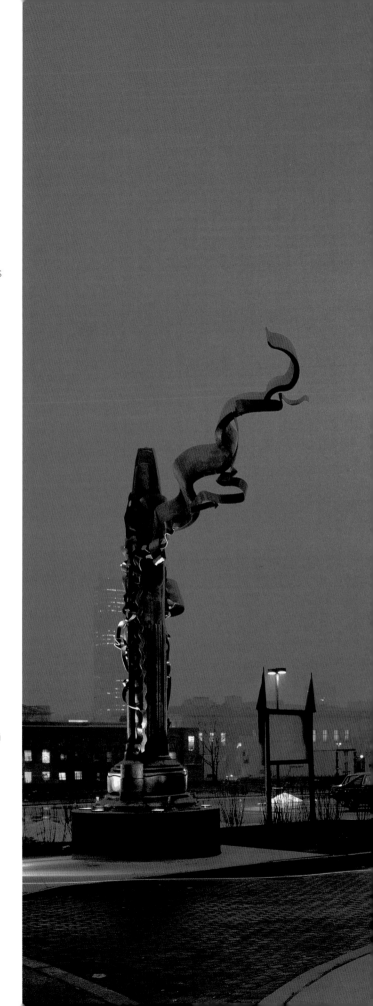

maquettes and small-scale models, and then the eventual three-dimensional fabrication. He concentrates on proportion and correct scale relationships. Space, rhythms, focus, and instrumentation of drawings are scrutinized. Drawing is referenced during the fabrication process in order to interpret the flow of surface movement.

Beyond drawing and subsequent aspects of each commission, collaboration continues, especially within Paley's team. Challenges of site logistics and fabrication posed by unique projects often require special design and preparation. Paley Studios Ltd. supports each project throughout the entire process from contractual agreements through structural engineering, forming and forging metals, surface finishing, and finally, to site installation.

SITED WORK

A 1986 pencil drawing materialized into a branching ceremonial archway commissioned by the Redevelopment Authority of the City of Philadelphia for its Museum Towers. Titled *Synergy* [*fig.8*], it is composed of a pair of twenty-five foot vertical steel sculptures rooted in an urban landscape. The vigor of these columnar clusters demarks the transitional borderline separating the residential complex (Museum Towers) from public space. From another perspective, *Synergy's* spreading foliage "frames" the sprawling city. Its rippling ribbons and swell of streamers arch sixty feet along its foundation. *Synergy* generates a sense of direction as well as a sense of movement, as if it were releasing a flight of steel into space. As described by critic Donald Kuspit, "They hold their own against the crowds who use the social spaces, and stand out with a greater individuality than any person in the transient crowd — be it of automobiles or people."⁹

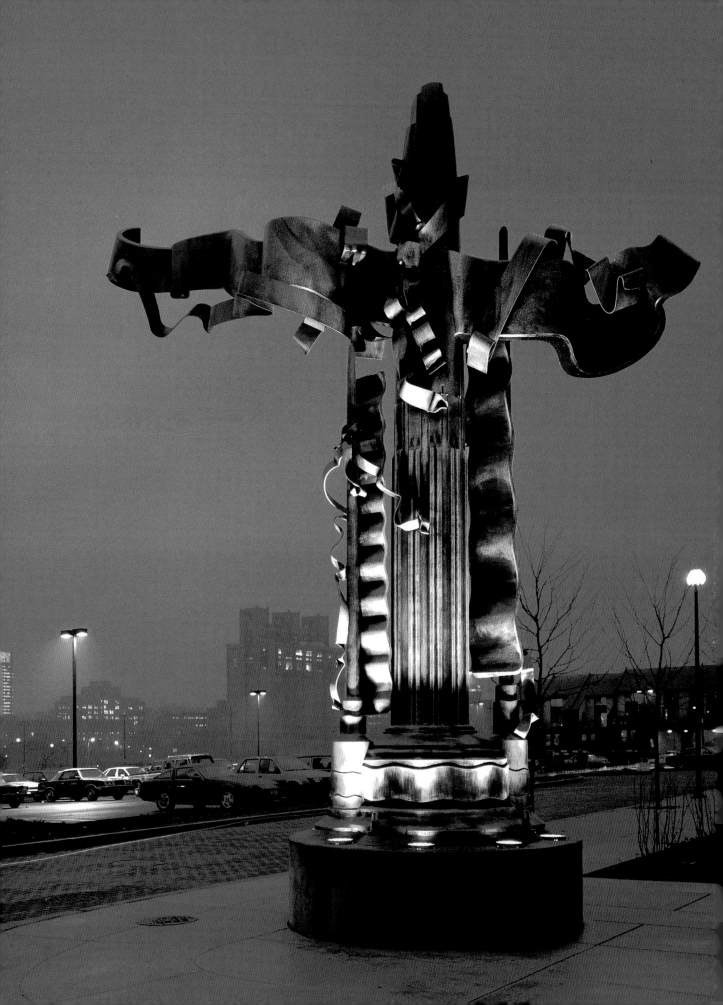

fig 9, **Epoch**, 2004
Formed and fabricated mild steel with polychrome finish
24 x 12 x 10.58 feet (7.32 x 3.66 x 3.22 m)
Commissioned by DC Commission on the Arts and Humanities,
Washington, D.C.
Paley Studio Archive, SS 2004.01

fig. 10, opposite: **Portal Gates,** 2000
Commissioned by the Naples Philharmonic Center
for the Arts, Naples, Florida for the Naples Museum of Art
Studio Archive: AG 2000.01
Photo credit: Carl J. Thome

The idea that Paley's *Portal Gates* (2000) [*fig.10*] at the Naples Art Museum in Florida owes anything to both the French nineteenth century painter Paul Cèzanne and to the twentieth century American abstractionist Stuart Davis may at first seem incredible. However, they have a relationship to Cèzanne's pictorial structure which imbued a vital spirit into the simplest inanimate objects. Paley's unique vocabulary of abstraction is also linked to Davis' rhythmic landscapes of geometric, flat areas and to his experiments with collage in the 1920s. Working from a cardboard model for the Naples *Portal Gates*, Paley established flat patterns that eventually were translated into metal. Cor-Ten and stainless steel as well as luminous bronze plates were cut, shaped, and assembled by welding them into a twenty foot high surface pattern. Abstracted palm and chevron silhouettes were overlapped, woven, and collaged together with ingenuity and vitality. In these *Portal Gates*, Paley may be playing a game of hide-and-seek with nature, but he still uses the visible world to challenge his creative powers. When lit at night from within the museum, light energizes the interval spaces through the open design of *Portal Gates* to draw visitors into this very "inner" experience.

At the bustling corner of 9th and G Streets in Washington, D.C. is *Epoch* (2004) [*fig.9*], a vivid, multi-colored, abstract steel sculpture assembled from formed, plated metal that was heated, cut, and bent. This technique of forming metal facilitates design changes during fabrication as contrasted with the more complicated forging method. In this urban landscape, *Epoch* seems to symbolize the daily journey of people in automobiles and on foot. Its effect is suggested by one of Paley's collaborators in

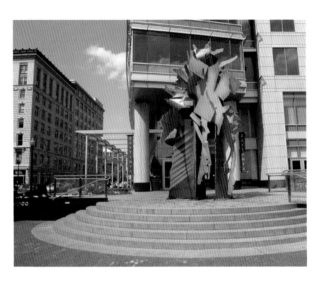

this commission, Dolores Kendrich, the Poet Laureate of Washington, D.C. Her poem commissioned for *Epoch* was stamped into the sculpture itself.

> *We are*
> *Flesh and blood*
> *Steel and skin*
> *Struggling within*
> *A linear light*
> *Toward one heartbeat*
> *That forges*
> *A sacred space*
> *An entrance*
> *To our fragile*
> *Dreams that rise*
> *Upon a muscle*
> *Of memory*
> *And wind.*

Form, the shape defined by line, is probably the most enduring element in garden design and is what is first seen when looking at a garden from a distance.

NAPLES MUSEUM of ART

5833

"Art keeps a
community's
wonder aliv[e]
become wh[at]
it wants t[o]

Anonym[ous]

"Art doe[s]
transform[...]
plain fo[...]

fig. 11, Bird's eye view of the artist viewing
a section of the Cleveland Botanical Garden
Kohl Gate (2004) during production.
Paley Studio Archive, AM 2004.01

Paley employs that view in his *Kohl Gate* (2004) for
the Cleveland Botanical Garden, in which the eye
automatically follows the warm, weathered steel
margins of his sculpture, like a linear garden at the
peak of its bloom. Tooth-edged diagonal forms are
juxtaposed with gentle curves to create dynamic
surface tension in the Cor-Ten steel garden gate.
As a ceremonial passage to a reservoir of botanical
information, the *Kohl Gate* represents distinct plant
shapes — pyramidal, weeping, columnar, spreading,
or round — which divide and define natural spaces
in the garden.

 Animals Always (2004), a civic archway at the
entrance of the St. Louis Zoological Park, does not
yield its full meaning until one takes the title seriously
and inquires into Paley's relationship to this assembly.
The artist understands that there is much to be
learned from the natural world. A spark of curiosity
draws a bigger flame — *Animals Always* promotes
a broader public understanding and appreciation of
the live collections in this zoo's care. It is easy to
connect with these animals because one recognizes
them from cave drawings down to the present.
Symbols in mythology, animals are "lionized"
throughout literature and art history. An animal
symbol is like a many-faceted diamond, with each
face bearing a different interpretation. *Animals Always*
characterizes nature as one. Here, life-size, often
free-standing steel animals epitomize the dignity of
wild animals that thrive in their natural habitats.
The completed composition is a harbinger of what is
both essential and inspirational for human existence:
the natural world.

 Organically ornate and wildly idiosyncratic,
Animals Always [*fig.15*] represents the state of the
natural world in the shape, movement, and line of

formed steel. With an uncanny ability to capture quiet, natural gestures, [*fig.14*] Paley coaxes slabs of steel patterns into a hair-raising menagerie of more than sixty animals from all over the planet. The archway's ornate biodiversity is sheltered under the protective shadow of a canopy of metal foliage. Not only is *Animals Always* an ambitious project in the scale of the city of St. Louis (noted for Eero Saarinen's monumental *Gateway Arch*), it rivals public sculpture in zoos around the world. The massive one hundred thirty foot figurative presence of *Animals Always* is a landmark for the St. Louis Zoo. The zoo playfully analogizes its dimensions as equivalent to the combined height of two giraffes, its width to three hippos standing shoulder-to-shoulder, its length to fifteen lions, and its weight to two hundred thirty-six Kodiak grizzly bears.[10]

CEREMONIAL PASSAGE

Paley's gates often evoke awareness of our journeys both personal and societal. As suggested earlier, Campbell's views of the hero's journey can be helpful in analyzing the impact and symbolism of Paley's sculpture. To apply the archetype of the hero's journey today is to better recognize a significant experience and to integrate it effectively into our lives. A hint of what to expect is gained as one accepts the call, crosses the threshold, makes spiritual allies, wins the boon, and finally returns with what one has acquired to serve a community. Ceremonial gates and portals placed at openings in academic spaces suggest movement from one intellectual state of being to

another. They mark a boundary and carry the associations of rites of passage. Such a gate is the *Stadium Entrance* (1999) at Florida State University in Tallahassee, a major work that spans more than thirty-five feet and rises thirteen feet to its highest point where its two sections come together and lock. This ceremonial portal remains closed until a special event, such as graduation, requires the hosting of a multitude. Then, what had been a barrier transforms into a point of crossing or passage for thousands of students and visitors.

In a 2004 interview, Paley discussed how his sculpture can vivify the passages of life, especially in an academic community. "The whole act of passage, walking through a structure, designates a certain point in time, and a certain activity. In the education process, when a student arrives at an institution of higher learning, it's like the triumphal archway in Rome. Before going to war or a campaign, they would walk out of the city through the archway. After experiencing the reality of battle, they would come back, either victorious or defeated. Walking again through the archway designated a given point in time. You literally, physically walk through it. In the same way, when the freshmen...first experience college: they walk through the sculpture; they're exposed to a given reality...they change. When they leave, again they walk through it. It's a metronome, a marking of time."[11]

Among Paley's acclaimed sited works is *Sentinel* (2003), a large sculpture placed within Administration Circle, a pedestrian space at the main arrival point for

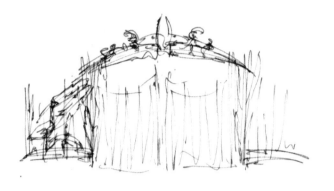

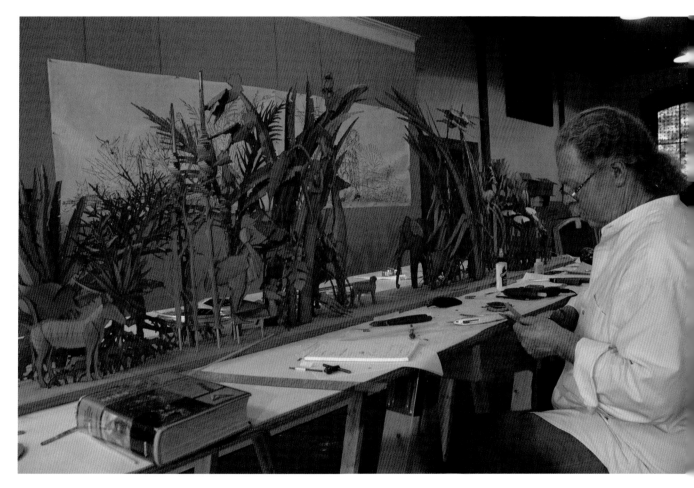

fig. 14, lower: Production work on wild ox
figure for **Animals Always,** 2006

fig. 15, opposite:
In situ night image of **Animals Always,** 2006
Formed and fabricated Cor Ten steel
40 x 130 x 12 feet (12.19 x 39.62 x 3.66 m)
St. Louis Zoological Park, St. Louis, Missouri
Studio Archive, AM 2006.01

visitors to the Rochester Institute of Technology. At
seventy-three feet high and weighing one hundred
and ten tons, *Sentinel* is a colossal steel and bronze
gateway that has re-characterized a former parking lot,
creating a dialogue between the architectural space
and the landscape design. Clearly a focal point for the
university community, it is an extroverted sculpture
that opens and interacts with the environment it brings
to life. Under an arched wing at *Sentinel's* base is a
gathering place which shelters people as they walk into
and through its monumental form. The space functions
for both casual socializing and ceremonial events.

The concept of ceremonial passage is well
illustrated in the several versions of *Portal* (illus.
pp.124–125). Beginning as a 1989 drawing, Paley's
concept evolved through several incarnations, but the
constant among them all was a boldly and minimally
designed post-and-lintel that evoked associations with
ancient ceremonial portals. The archaic Greek *Lion
Gate* (c. 1250 BCE) at Mycenae and the solemn, grand
passageways of the pylon temples of ancient Egypt are
among the precedents of Paley's re-visioning of the
ceremonial portal. Whether its scale is a two foot high
steel maquette (1990) or a thirty foot Cor-Ten steel
sculpture (2005), *Portal's* simple post-and-lintel
composition expresses better than any other
architectural element the changeless and eternal. With
its tapered pylons and flying banners, Portal stands
monumental, heroic, and timeless, recalling the
fortified presence of a citadel — a symbolic guardian
and iconic fragment of a civilization.

Transformation (2007), Paley's commissioned
entrance for Iowa State University's historic Morrill
Hall, is intended as a beacon of growth, guiding
viewers towards a renewed place of learning on
campus. At Morrill Hall's main portico, flanked on

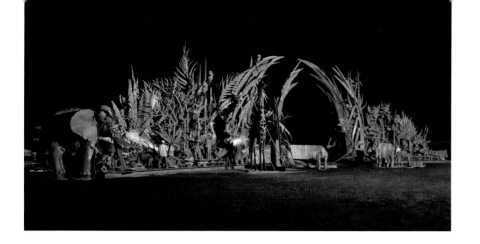

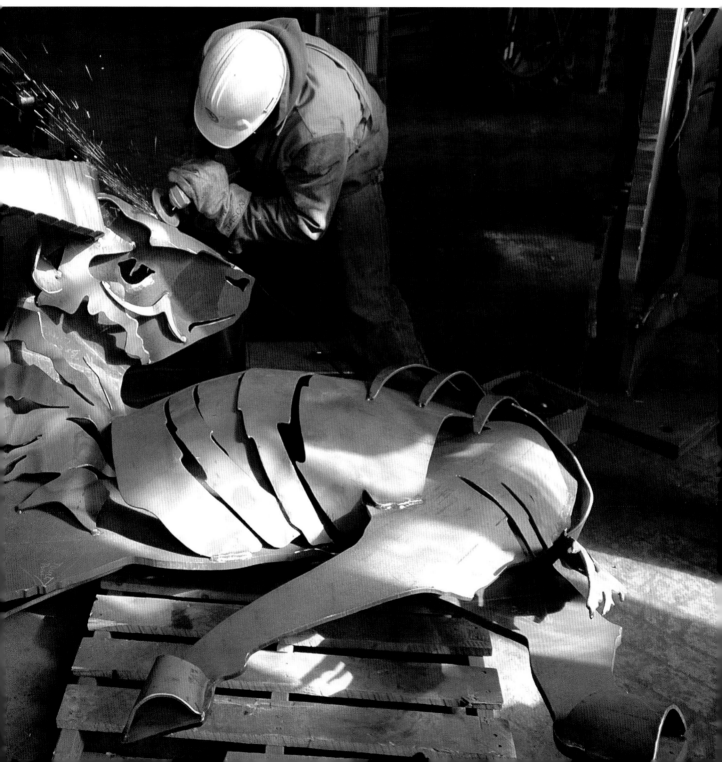

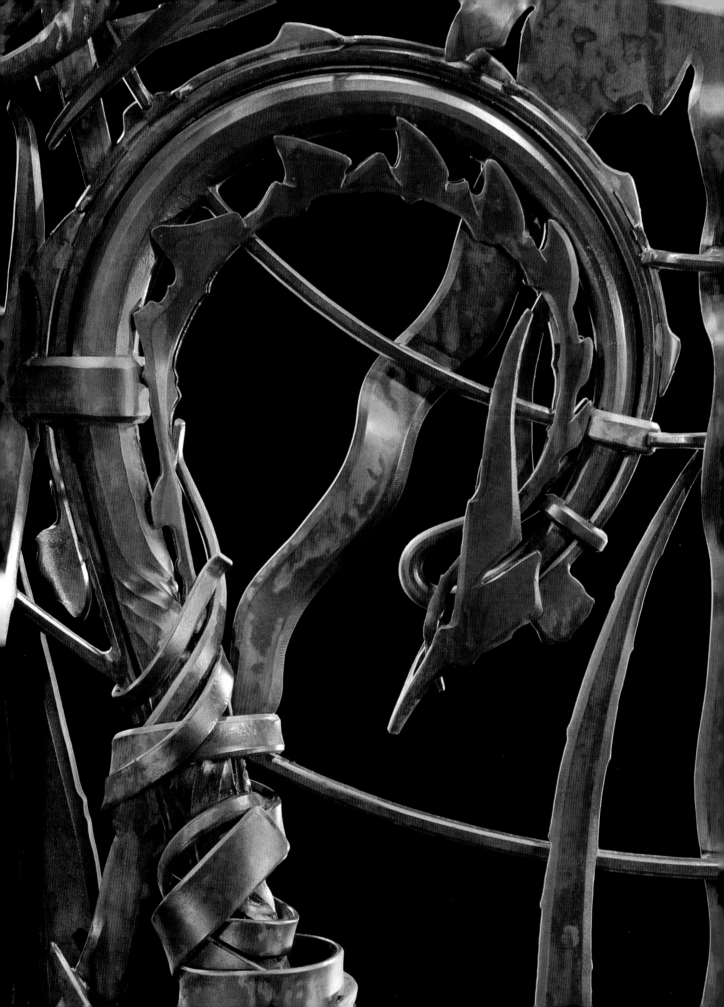

the north and south by a flight of steps, are the undulating, geometric steel planes of *Transformation*. As the sun rises, the sculpture's polished surface mirrors the sun's light and creates a symbol of the light of learning at this teaching institution — dispelling the darkness of ignorance. The organically alive, stainless steel matrix clearly reverberates against the red brick nineteenth century building.

Transformation reaches out from the core of the building like an orchestra of inspiration greeting students, faculty, alumni, and visitors. It is a signature sculpture rooted in Paley's humanistic and naturalist ideal, but it is also a tangible metaphor of the building's transformation from the historic campus structure to a contemporary art museum and learning center.

FORGING AN IDIOM

The earthly adventure and the spiritual passage, usually considered two separate things, are sometimes regarded as components of the same experience. Paley's *Design Study for the Good Shepherd Gate at the National Cathedral* (2007), an eight foot high steel model for the Washington National Cathedral, reverently accommodates the experience of a place already brimming with meaning. With its Gothic style architecture, the National Cathedral is a landmark place of national focus where presidents often speak and where the Rev. Dr. Martin Luther King, Jr. preached his last Sunday sermon.

The *Good Shepherd Gate* was created specifically for a pointed arch doorway that leads into one of the many small chapels, the Chapel of the Good Shepherd. Like the completed gate, *Design Study*, with its numerous forms and intricate design, is a labyrinthine passage forged into an expressive idiom. Paley called it one of "the most complex forged pieces [he] had ever

done."[12] Like a labyrinth, the composition of the gate design has no dead ends, but winds in a circuitous pathway to the center.

The gate represents metamorphosis. The artist has transformed the famous Twenty-third Psalm of David from the Bible into an ingenious system of closure and disclosure, creating a forged layering of images that resonate from the psalm.

> *The Lord is my shepherd; I shall not want.*
> *He makes me lie down in green pastures;*
> *He leads me beside still waters.*
> *He restores my soul...*

"The shepherd is the gate and Christ is the good shepherd," Paley has explained. Narrative elements symbolizing guidance, abundance, and regeneration are gathered into a shepherd's crook [*fig.16*] that rests peacefully adjacent to rippling, banner-like steel waves and a large seed pod. Paley interprets truth, wisdom, and purity with an image of light in the form of a golden halo shining down from near the apex of the pointed gate. A quotation from the Gospel of St. John is displayed nearby: "I am the gate for the sheep. I came that they may have life and have it abundantly." Paley's gate is a tool for meditation — a spiritual passage — from one world to another, from the known to the unknown, and even from darkness into light.

A description of the twentieth century sculptor Alberto Giacometti particularly fits Albert Paley: "As his fingers draw presence out of the void, his work tests his talent to find a fact."[13] Whether civic or religious, the iconic value of a gate or portal has long been determined by more than its utility. Albert Paley's portals and gates enhance the experience of a place, and they continue the long-term development of a

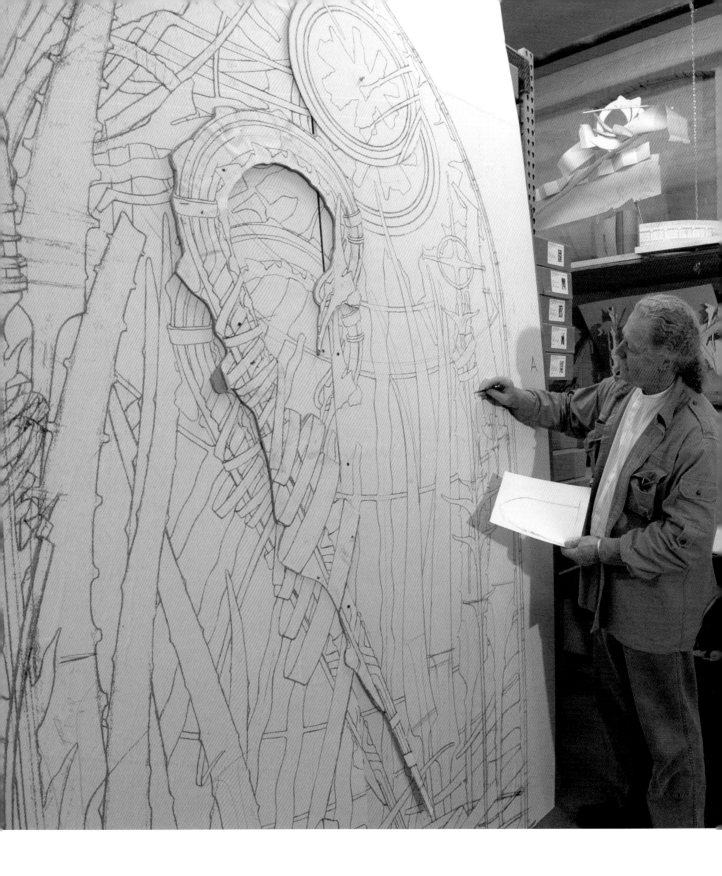

theme that can be traced back to his earliest work. His fingers draw presence out of iron and steel. They have produced a "fact" of experiences of body and space, and they bridge a deeper understanding of what it means to experience "passage."

1. Campbell, Joseph, *The Hero with a Thousand Faces*, Princeton: Princeton University Press, 1973, p. 30.

2. Lovenheim, Barbara, "The Art World's Man of Iron," *The Wall Street Journal*, Leisure & Arts Section, April 17, 1984.

3. Schmertz, Mildred, "From Lines in Pencil to Forms in Space," from an interview with Albert Paley, *Inspiration & Context: The Drawings of Albert Paley*, Rochester, New York: Memorial Art Gallery of the University of Rochester, 1994, p. 9.

4. Giovannini, Joseph, "In New Ironwork, Hints of a Renaissance," *The New York Times*, Section.C, June 16, 1963.

5. Lucie-Smith, Edward, *The Art of Albert Paley*, New York: Harry N. Abrams, Inc., 1996, p. 44.

6. Kuspit, Donald, *Albert Paley*, Milano, Italy: Skira Editore, S.p.A., 2006, p. 26.

7. Yarrington, James, and others, *Sentinel: the Design, Fabrication, and Installation of the Monumental Sculpture by Albert Paley at Rochester Institute of Technology*, Rochester, New York: RIT Cary Graphic Arts Press, 2005, p. 99.

8. Schmertz, p. 4.

9. Kuspit, p. 20.

10. http://www.stlzoo.org/home/featurednews/animalsalwayssculpture.htm; accessed May 22, 2007.

11. Yarrington, *Sentinel*, p. 103.

12. Paley quoted in an unidentified article by Stuart Low, Paley Studio Archive.

13. Drot, Jean-Marie, "*A Man Among Men: Alberto Giacometti*" Online video clip at: http://www.ubu.com/film/drot.html; accessed April 20, 2007.

fig. 17, Paley drawing the large scale pattern for the **Design Study for the Good Shepherd Gate at the National Cathedral** in his studio at 25 North Washington Street, Rochester, New York.

RECONFIGURATION | HOMETOWN PERRY, IOWA

WILLLIAM L. CLARK President, Hometown Perry, Iowa

Reconfiguration Archway (concept drawing), 2002
Black marker on rice paper
19 x 23 inches (48.3 x 58.4 cm)
Paley Studio Archive, GA 2006.01

opposite: **Reconfiguration**, 2002
Assemblage: mild and stainless steel,
found objects, painted finish
Two archways:
25.6 x 28 x 7.3 feet (7.80 x 8.53 x 2.23 m)
and 19 x 24.5 x 6.5 feet (5.79 x 7.47 x 1.98 m)
Architect: Wetherell Ericsson Leusink Architects,
Des Moines, Iowa
Commissioned by Howard F. and
Roberta Green Ahmanson and Hometown Perry
for Soumas Court, Perry, Iowa
Paley Studio Archive: GA 2006.01
Photo: Robert Reynolds

Paley's *Reconfiguration* arches, which stand at the entrances to Hometown Perry, Iowa's Soumas Court, are truly community art pieces. Not only are they built from objects — farm equipment, railroad materials, even a piano sounding board — donated by community members, but metalworkers from Perry helped to assemble the pieces over a two-week span while Paley was in residence. After some initial resistance, as the welders wondered what they were doing working on a piece of art, they came to feel ownership in the finished structure that now encapsulates the history of the town. Their reaction is perhaps emblematic of other public responses to the sculptures once they were installed. Letters to the editor of the *Perry Chief* show that initial reaction to the arches was mixed, but several writers eventually decided that "they are different and unique and something every town this size doesn't have," and they "dramatically symbolize the town's history."

Paley was originally commissioned to create gates at either end of Soumas Court, but decided that arches were preferable because they invite people in, rather than keeping them out. Since their installation in 2002, the arches have invited the community into an ongoing conversation. The value of public art is that it starts a discussion, making art a topic worth talking about. And the stories around the piece are what make it meaningful; Paley likens an art work to a vessel that is filled up with viewers' interpretations. On any given day in Perry, you might see groups of two or three people peering up at the arches, trying to spot the augers, wagon wheels, and other pieces of Perry's history collected there. Paley has noted that the work is here, not because he was able to make it, but because the community felt it would be of value. People identify with the history embodied in *Reconfiguration*, and with the community spirit that made it possible.

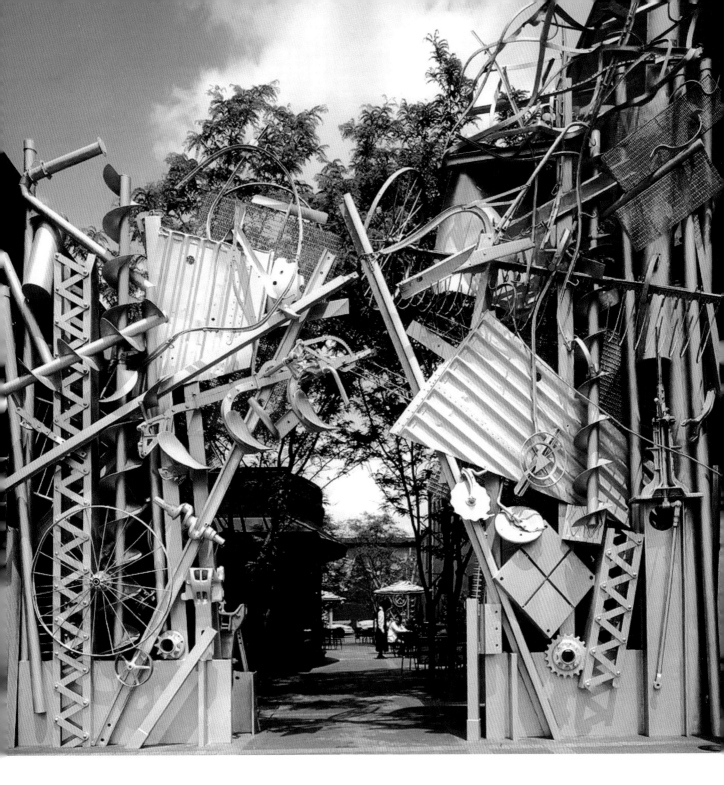

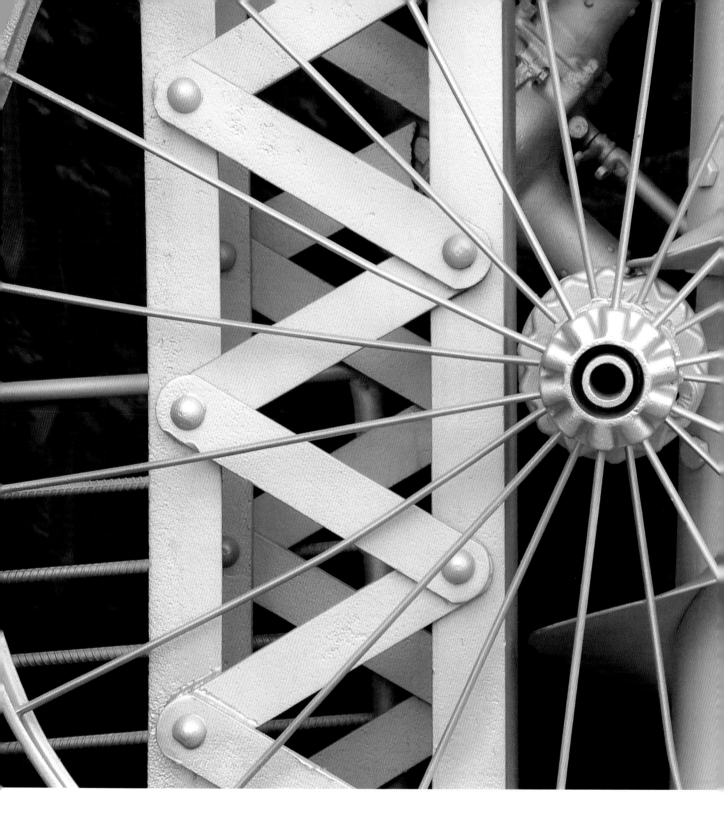

POEM FOR "RECONFIGURATION"

Bell, gong, and cymbal clang when struck,
raising within them the old music of labor,

vast choirs of molecules praising
the artisans' hands on the burning ladle,

their backs bent sore at the ringing anvil,
forging chords with hammer and tong.

For all things beaten into shape, or cast,
or welded together, auger and plowshare,

bridge and rail, cling always to the music
that went into making them, the notes

that fell with every drop of sweat,
even the plunk of a lunch pail set down

among the curls of shavings on a bench,
and the clink of the wrench knocked off

to the oily floor. Every cough and curse,
every laugh, good joke and bad, the snap

of the spark at the tip of the torch, the chirp
of the foreman's whistle, every sound

of life lies in the girders, rods and rails
that shelter us, that carry us across the years

working and singing, talking and laughing,
telling our stories, passing through.

TED KOOSER U.S. Poet Laureate, 2004

Poem for "Reconfiguration" was
commissioned by Hometown Perry, Iowa,
and is reprinted by permission
of Ted Kooser.

Detail of **Reconfiguration**, 2002
Photo: Albert Paley

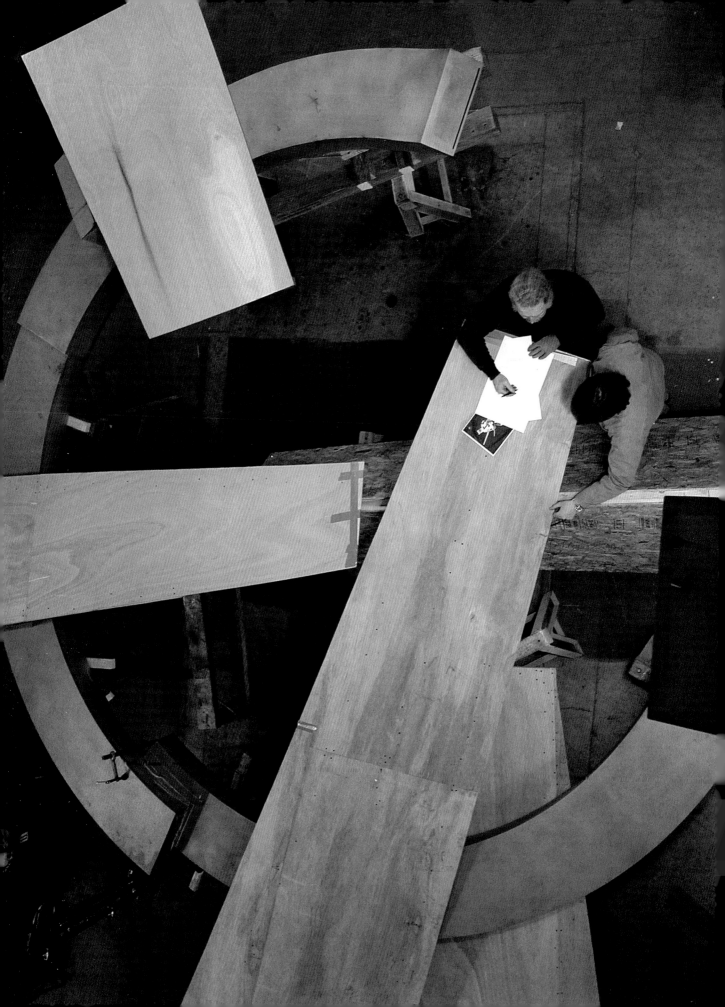

ART INTO ARCHITECTURE | CONVERSATIONS WITH ALBERT PALEY

MARK C. ENGELBRECHT, FAIA Dean, College of Design, Iowa State University

Joining the mid-day stream of students, staff and faculty in a kind of "promenade" from my college and into the center of our campus, the opening of the new academic year seemed as fresh as the late summer breeze. The students, bronzed and energized by summer-long adventure, multiplied their coursing numbers by countless friends who joined by cell-phone, and the entire troupe, real and "virtual," took on an almost festive nature, sweeping me along. Finally, I managed to come to rest on a stone bench sheltered by one of the pine groves edging the central green of our historic Iowa State University campus, and I began to put down this brief personal reflection on my friend, the sculptor Albert Paley, and the work and exhibition at the refurbished Morrill Hall that brings his unique vision to our academic community.

As we shall see, it came as no surprise that this stroll among the academic crowd, young and glittering as well as old and seasoned (like the author), prompted the beginning of this brief essay, because the title of the exhibition is *Albert Paley | Portals & Gates*, and his work, part of the public art program of our university, dramatically embellishes the entry of the restored Morrill Hall. A university is almost a material metaphor for the "act of passage," and the very real physical movement of the crowd across campus is only the most basic, but perhaps most evocative, of these metaphorical dimensions of passage. There is also, as we shall see, an interesting, rich rhyme resonating between the work of Albert Paley and the movement of those I've had the occasion to join on this brilliant day. All of this proved sufficient to bring me to the first words of this reflection, requested by my good friend and colleague Lynette Pohlman, Director of University Museums, when the Paley exhibition was in its early planning process.

It had also been my good fortune to spend nearly a month of the summer touring Scandinavia with a party put together and graciously hosted by our friends and benefactors Roberta and Howard Ahmanson, and which also included Albert Paley and his wife, Frances. That trip was a highly organized adventure in search of the people, places, and artifacts that propelled the cultures of the Scandinavian countries from a worshipful neo-classical preoccupation into the late nineteenth century regional romanticism that, ultimately, powered the modernism that so many of us have come to identify with the Nordic nations. This journey, intellectually and physically exhausting as it had been, was literally a life-changing event, and my conversations with Albert Paley during the course of the travels contributed immeasurably to the richness of the experience.

"I have the ability to see — really see — small things." A startling comment from the artist Albert Paley, made during one of many conversations it was my great pleasure to have with him during those weeks of travel together in Scandinavia in the late summer, and, more recently, seated in his office a level above the floor of his studio in Rochester. Hardly a place of "small things," this studio, an industrial hall populated by Albert's staff wielding every manner of torches, burnishing machines, hammers and tongs (literally), at work on large-scale metal sculptures, furnishings, and one magnificent gate bound for a chapel of our National Cathedral in Washington. The space is more an inspired "auto-body shop" than an artist's studio, and certainly not a place that brings the visitor to dwell upon the elemental — the "small." Not, that is, unless one has had the privilege of walking and talking with this unique artist, Albert Paley, through some of the most interesting places in the

pp. 42: Bird's eye view of Paley (top) and
associate during the production of **Sentinel**, 2003

opposite: **Portal Gates** (1980) in the New York State Senate
chamber of the State Capital Building, Albany, New York.
Forged and fabricated mild steel, brass, and bronze
each: 13.5 x 9 x 5 feet (4.11 x 2.74 x 1.52 m)
Paley Studio Archive, AG 1980.01

great urban centers and landscapes of Denmark, Finland, and Sweden, and now, around three of his most famous monumental sculptures in his city of residence, Rochester, New York. In spite of the increasingly impressive scale of his work, the artist remains attuned to the essential human and material realities that inform the shapes, processes, and ultimate meaning of his creations. He is an artist of elemental vision.

These recent conversations with Albert were not the first for me, and my interest in his work predates even our original meeting in 1998 when the College of Design invited him to lecture here at Iowa State University. His unique vision and artistry first projected itself into the ranks of architects with the installation of his memorable *Portal Gates* to the senate chamber in the capitol building of the state of New York, in Albany. The American Institute of Architects recognized this notable achievement by presenting Paley with its Award of Excellence for Art in Architecture in 1982. In that same year I determined to take a side-trip from business in New York to travel with my friend and associate, Charles Griffin, to Albany to view these gates and, of course, the restored capitol building itself, a work, in part, of the great nineteenth century Boston architect, H H Richardson.

We were propelled in this brief excursion by the interesting time that the practice of architecture and all of the allied design disciplines were passing through with the ascendancy of the "post modern." Whatever else that movement might have effected, for good or ill, it did bring a renewed interest in the historic fabric of our built environment, including a fresh appreciation for the role of ornament and the arts as integral to its full expression. As architects, we stood amazed in the face of the intricately wrought decorative effects that had been at the disposal of our predecessors, like Richardson, and that had long been suppressed by both the modernist aesthetic and contemporary construction practice. We hungered for some inspiration for a renewal of this tradition, and the gates of Albert Paley at Albany provided a glimpse of a way forward. They stood so much at home on the threshold of that great Richardsonian space in the capitol building, expressing what was new and comfortable to us while also providing a wonderfully consistent visual introduction to the opulent nineteenth century chamber beyond. It was magical, and, in my view, remains so.

But the artist whose work had brought us as architects to Albany had not arrived at the task with a mind to dramatically intercede in the theoretical disputes of our professional community. He had arrived at this important project from a route that is only available to the artist, for, once provided the opportunity, Albert Paley had become consumed by art: drawing, sculpting, modeling, and, finally, seizing on the making of exceptional objects for adornment as a satisfying combination of his feel for materials, craft, and poetic expression. He has related with some passion how all of these various media literally responded to his personal touch, eschewing drawing except for itself, and priding himself on the ability to begin any piece of work with some core reality — a jewel, particular metal, bodily shape or gesture — as an armature for the creation of the final work. "Design," as we architects might understand the matter, happened in the event.

Albert Paley's processes of making art changed, inevitably, with the change of the scale and circumstance of his projects, and it was with these new

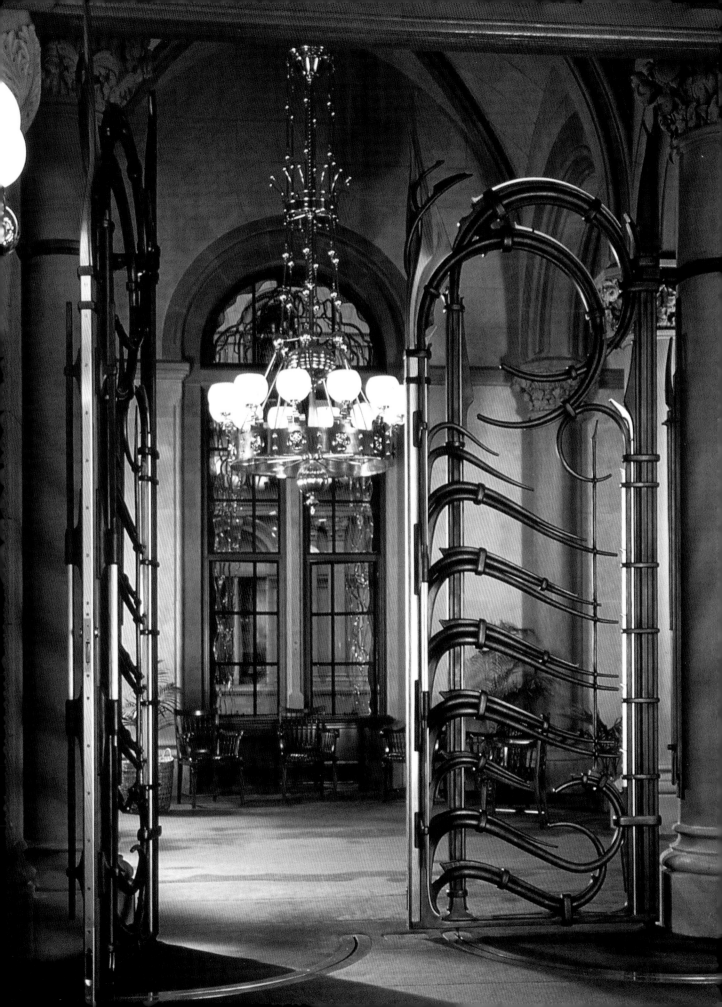

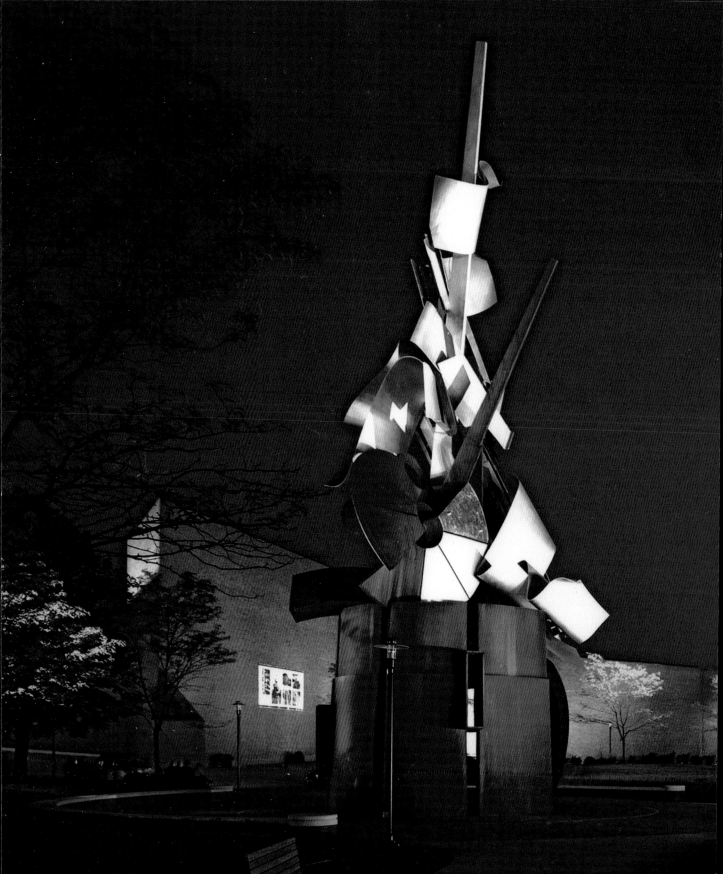

Sentinel, 2003
Formed and fabricated Cor-Ten steel, stainless steel, and bronze
73 x 30 (dia.) feet (22.25 x 9.14 m)
Rochester Institute of Technology, Rochester, New York
Paley Studio Archive: SS 2003.01
Photo: Courtesy of RIT School of Photographic Arts and Sciences,
Big Shot, night photograph on September 12, 2004

techniques, quite as much as the content of the work, that his association with architecture began to fully unfold. This is no small point, and Albert has often expressed the personal challenge embedded in a new approach that required a new rigor in the preparation and expression of his artistic intent — design if you will — as a necessary prerequisite for the presentation and execution of his larger new commissions. Premeditation of this sort is, of course, the stock-in-trade of the architect, but this process, the design process, necessarily edits out any immediacy with materials and their manipulation, and Albert Paley's tradition and preference, as he says, remain with these direct exchanges between the body and the media of expression. The ongoing work of this artist, then, is of particular significance to me because it retains, as do many of the projects included in this exhibition and, memorably, the new Morrill Hall entry, the palpable expression of the hand-wrought, even though the processes that actually produce the work are more objective and abstract.

Aside from this matter of technique, or process, the projects displayed in this exhibition provide another progression of Albert Paley's work from the alluring objects of his early career toward the architectural ambitions that now inspire him. These gates, portals, and passageways valorize perhaps the most fundamental, even archaic, defining reality of architecture, the "threshold." Separating without from within, dark from light, warmth from cold and often one psychic state from another, these architectural "passages" require human action to be fully realized, so it is unsurprising that they attract the interest and effort of a sculptor so committed to a physical interaction with his materials.

Looking out from the grove mentioned in the

opposite: Detail of Iowa Sculpture Proposal –
Morrill Hall
(*Transformation*), 2005
Foam core, cardboard, pen, paint, glue
25.5 x 48 x 29 inches (64.8 x 121.9 x 61 cm)
Paley Studio Archive, PM 2005.37

opening paragraphs of this reflection, the architecture of the neo-classical "temples" surrounding the central green speaks clearly, and evocatively, of the "threshold" and attendant human passage. These wonderful classical porches, with their amazingly diverse form and content (for the architecture buff the orders selected for the portals of Beardshear, old Home Economics and Curtis Hall provide an interesting puzzle), valorize the countless daily transitions and transactions that define the rich diversity, intent, and motion of a university culture. Nor are the more romantic architectural characters, such as Catt Hall, the Campanile, and, of course, Morrill Hall itself, without memorable entry sequences. Even the newer central structures, like the Parks Library and Gerdin Business Building, are not absent thoughtfully contrived "thresholds."

In one way, I suppose, the commission that this exhibition celebrates, the work that enhances the entry porch to the refurbished Morrill Hall, recalls that seminal work in Albany that so attracted us some decades ago. There, as here in Ames, Paley's concept was integrated into a nineteenth century building which, at the time it was built, reflected the latest style, a Romanesque derivative much in favor with Richardson and his friends from New England, including the great landscape architect Frederick Law Olmsted. Both installations distinctively mark threshold experiences fundamental to the larger architectural fabric, adding commentary to the experience of entry. But, as these two projects and the accompanying exhibition clearly show, Paley has moved on from the Renwick and Albany statements, as well as a similar earlier commission at the Renwick Gallery in Washington, D.C., seminal as they were at the time.

Although I must very carefully qualify my limited credentials in these matters, I would say that Albert Paley signifies in this new work at Morrill Hall a more complete expression of those elemental themes that have informed his trajectory than the more austere geometries of the early gates. He seems to me, first of all, one inspired by the natural phenomena of the world (he is a dedicated gardener) and the artful gesture that it compels in response. From his drawings, so free in those beginning, underlying marks that yield the final, hardened geometries, to the physical struggle that makes artful demand on inert material, there exists the imprint of the inspired gesture. Although Albert Paley is known as a great sculptor, I imagine him as something of a "performance artist:" an artist who leaves the trace of his movement in hardened material. And this artful gesture in space brings us once again to the realm of architecture, a world that Albert Paley has very much come to look upon as his ultimate artistic destiny.

The base of his dramatic and monumental sculpture in the entry court to the Rochester Institute of Technology, Albert Paley's academic home, is shaped in a way that cannot be considered in other than architectural terms. A fully rounded space, beautifully contoured and illuminated for human occupancy, literally supports this memorable work and invites involvement with the towering sculpture from within its very core. This space is also beautifully constructed, the double steel walls expertly crafted and smooth to the touch. "Small things," these elegant details bring the massive metallic forms together in such a way that invite our touch.

Of course, the work at R.I.T., entitled *Sentinel*, is a primary example of Paley's monumental sculptures

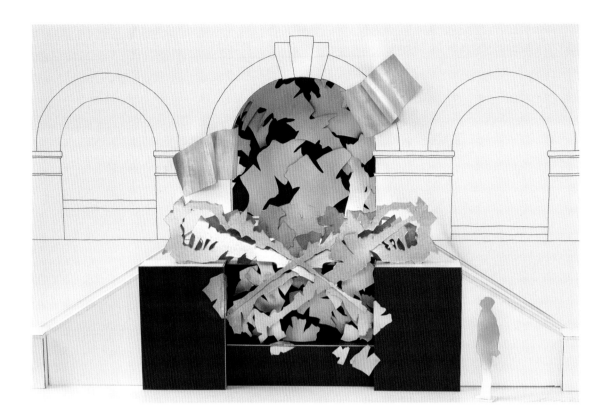

designed to enhance public spaces associated with large corporate or institutional projects. He obviously enjoys these opportunites, but expresses some frustration with the timing of his involvement. So often, it comes post-construction as an obligation to "public art" required by many institutional works and therefore presents to him a field of play already circumscribed by architects, landscape architects, and clients. For an accomplished, well seasoned sculptor like Paley, this timing often means a lost opportunity for true collaboration and a work, although successful in itself, somewhat diminished by the process. He has frequently remarked on the pleasure he has taken, and the significant insights he has gained, from those projects in which he was engaged with the design team from the early days of the work, as with *Sentinel*. I think this added dimension is manifested in the final result. (As an aside, I would recommend a visit to the campus of Rochester Institute of Technology for anyone interested in large-scale "high-modern" design as practiced in this country during the boom years of the early sixties — and for an Albers mural gracing the lobby of the administrative tower adjacent to the common open space hosting Paley's work.)

Although at this writing I have not yet had the opportunity to personally engage the threshold work that Paley proposes for Morrill Hall, an inspection of the drawings and model of the project has me very much looking forward to the experience. The arched entry and stair associated with the restored building have permitted the artist a chance to realize a work that fully envelops the visitor and, as such, must be considered as much a part of the architecture as the original nineteenth century masonry fabric. Although some will probably question the juxtaposition of the very personal forms and unusual materials of the Paley work within the context of the Romanesque order of the original hall, I am prepared to fully appreciate the gesture. I am also prepared to assess the sculpture as a work of architecture, sheathing, as it does, the original form of the entry vestibule and shaping a space uniquely attuned to the act of passage. I am reminded, in this regard, of some of the most famous Renaissance artists/architects, such as Michelangelo, who happily, and evocatively, sheathed pre-existing work, such as the Palazzo Farnese in Rome, in decidedly fresh forms and materials.

But the entry vestibule to Morrill Hall will not be

opposite: **Iowa State University Project Proposal**, 2005
Red pencil on paper
36 x 24 inches (91.44 x 60.96 cm)
Paley Studio Archive, SCU 2005.01.02

the only architectural work of Albert Paley that will be near at hand. Although the arches that grace either threshold of the courtyard associated with the Hotel Pattee in Perry, Iowa are conventionally viewed as entry statements, I prefer to see them as two facades framing a really handsome exterior space, or outdoor room, best considered in largely architectural terms.

I think that these two works of Paley, the entry to our beloved Morrill Hall, at Iowa State, and the two arch-like "facades" framing the courtyard in Perry, will become essential to the final accounting of this great artist's trajectory from body art, through impressively scaled free-standing sculpture, to its ultimate expression as architecture. We are privileged, through these works, to become personally acquainted with the unfolding of an artistic vision and its passage toward a particular destiny. It will be a very interesting process, this final step from sculpture to architecture, because Albert Paley insists that his personal imprint, the unique gesture of making and authorship, be manifest in each and every work, no matter its intent, material, or scale. This is an architecture that will come to exist without elaborate documents or typical construction regimen. But I have no doubt that it will come to exist.

On a cool, silvery evening in late July, Albert and I left a remarkable dinner hosted by the descendants of the famous Swedish artist, Carl Larrson, at his home in the magical countryside of Sundborn and walked along a small river toward our waiting van. A few hundred feet distant, on the opposite bank of the stream, we noticed a small cottage, its door open to reveal a tall, gaunt figure illuminated by dim lighting, at a work bench within. "It's a smith!" Albert exclaimed, and upon approach and entry, we did indeed encounter a young craftsman standing in

the midst of the tools and furnaces of his trade. I thought this to be some sort of tourists' venue, but our conversation soon revealed an educated young man (he was well aware of Albert's reputation) working late into the evening at a craft that he hoped might be both of service and artistically rewarding. It was a small, functional, yet ancient and elegantly sited building, and Albert immediately fully occupied it, both physically and psychically. Had the fires not been banked for the evening, he might have taken up hammer and tong and set to work.

This twilight image in the young Swedish smith's workshop has frequently reoccurred to me as I labored through this brief essay. Albert Paley, with his hands on the essential tools of his art, enfolded within a humble, yet evocative architecture, seemed to somehow express the origin and destiny of his career. In spite of my effort, he has refused to be understood in terms of the customary phases of an artistic life, explaining his trajectory simply in terms of evolving opportunity. With the commission for Morrill Hall, I am very pleased that our Iowa State University has provided to this great American artist what may become another threshold opportunity. From here he will almost certainly find the occasion to begin to create an architecture, and, although I have no clear idea of how he will manage to personally fashion this work, there can be little doubt that it will manifest itself as a truly unique artistic statement that comes to exist as a poetically grounded, powerfully rendered and fully accommodating space — the lessons of the "very small," wrought at an enveloping scale.

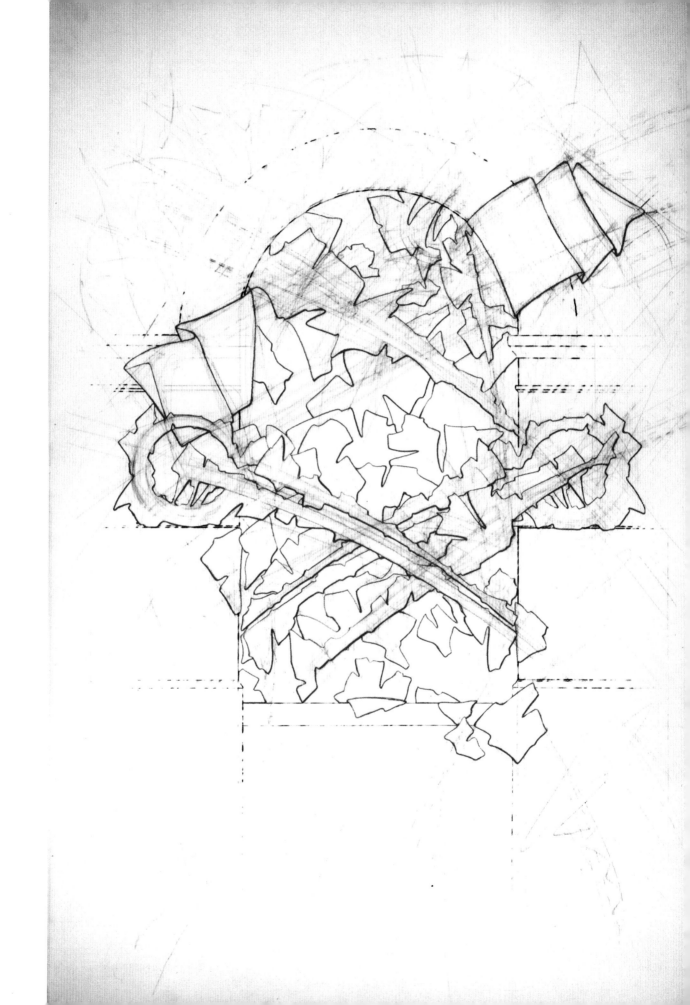

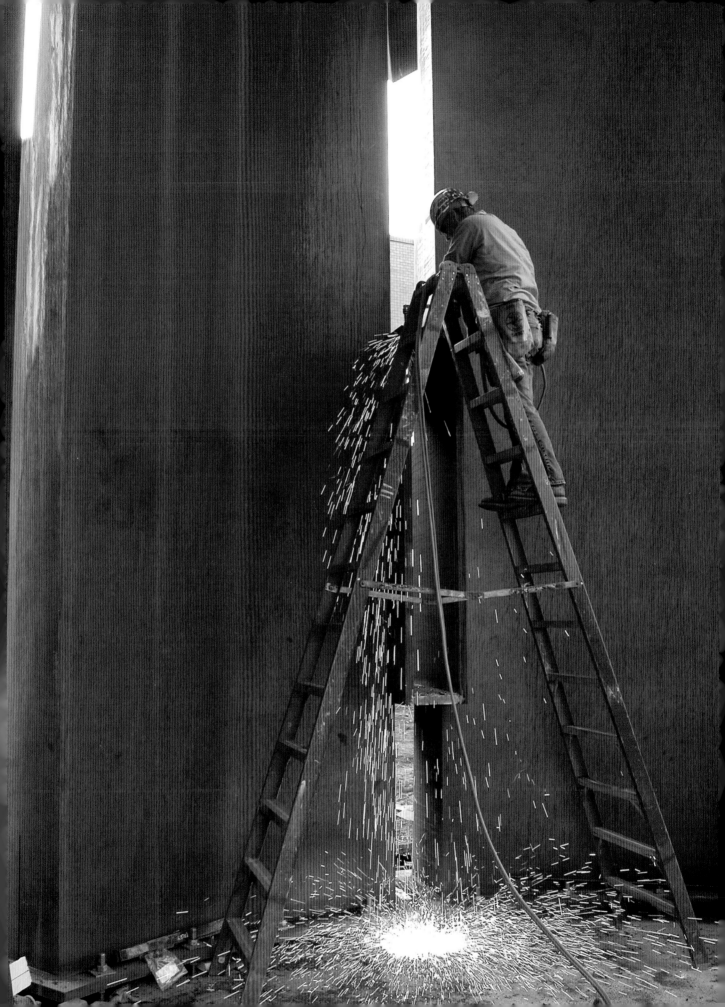

WORKS

PORTAL GATES 1974

p. 52: Detail of production work on
Sentinel, 2003
Paley Studio Archive, SS 2003.01

upper left to right:
Study for Portal Gates, 1972
Ink on paper
each: 9 x 12 inches (22.9 x 30.5 cm)
Paley Studio Archive:
GA 1972.01.02; GA 1972.01.03

lower: **Study for the Portal Gates,** 1972
Ink on board, 27.5 x 37.25 inches (69.85 x 94.62 cm)
Paley Studio Archive, GA 1972.01.18

opposite: **Study for Portal Gates,** 1972
Ink on paper
9 x 12 inches (22.9 x 30.5 cm)
Paley Studio Archive, GA 1972.01.15

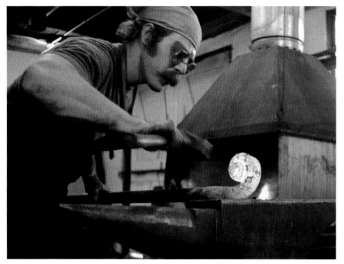
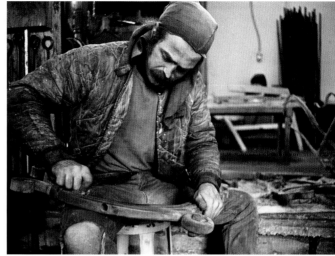
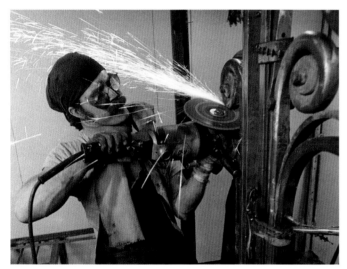
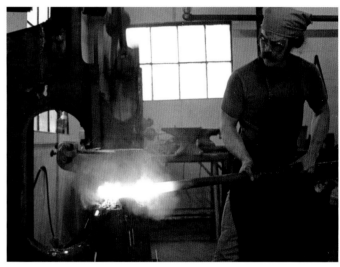
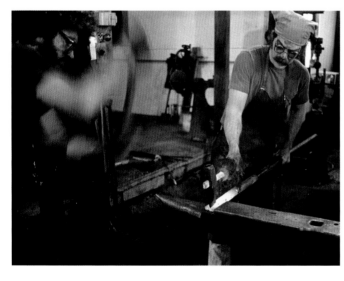
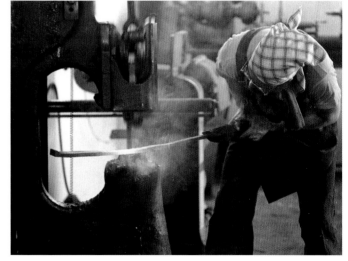

Production of **Portal Gates**
(*Renwick gates*) in artist's studio
at 1237 East Main Street, Rochester,
New York, 1974.

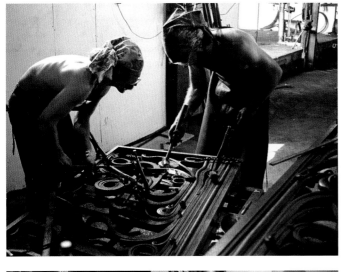
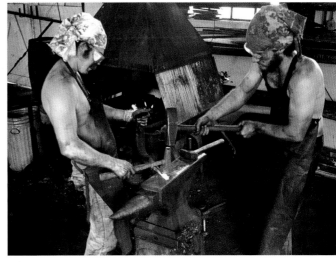
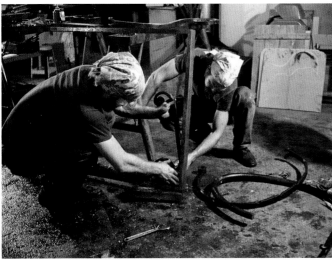

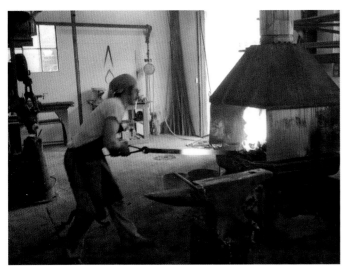
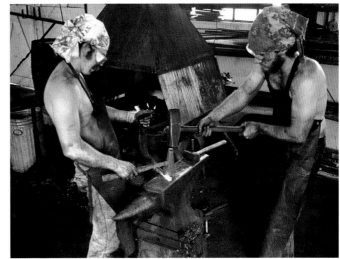

Interpretation of the Portal Gates, 1992
Graphite on paper
48 x 35.5 inches (122 x 90 cm)
Commissioned by the Renwick Gallery,
National Museum of American Art,
Smithsonian Institution, Washington, D.C.,
in observation of its 20th anniversary.
Paley Studio Archive, GA 1992.01

opposite: Portal Gates, 1974
Forged and fabricated mild steel,
brass, bronze, copper
90.25 x 72 x 4 inches (229.2 x 182.9 x 10.2 cm)
7.5 feet x 6 feet x 4 inches (2.29 m x 1.83 m x 10.2 cm)
Signed middle vertical "1974 Albert Paley"
Smithsonian American Art Museum,
Washington, D.C.,
Commissioned for the Renwick Gallery,
1975.117.1a-b
Paley Studio Archive, AG 1974.01

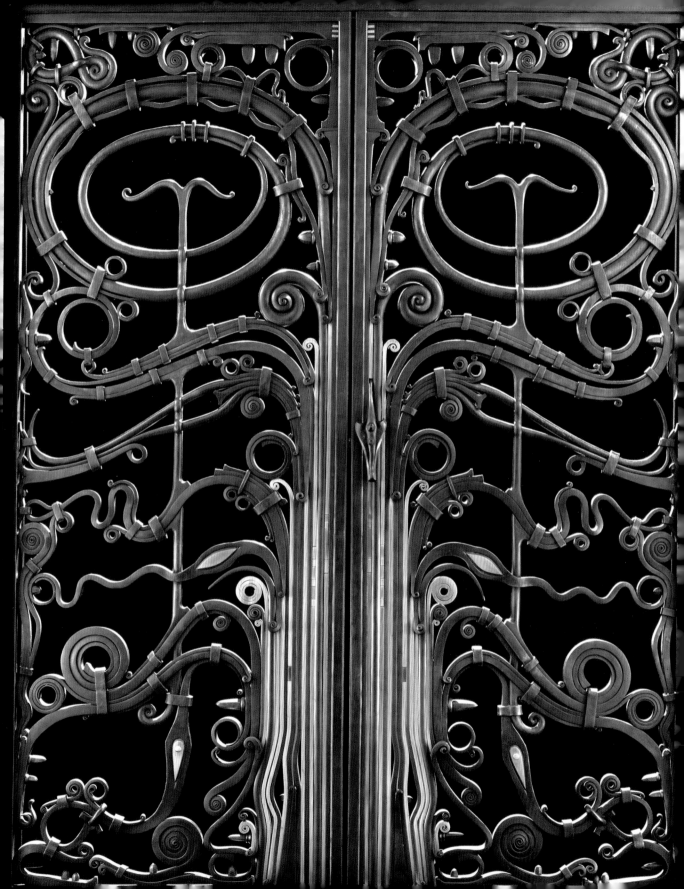

RECTILINEAR GATE 1976

Rectilinear Gate, 1976
Forged and fabricated mild steel;
black patina
90 x 35 x 5.5 inches
(229 x 89 x 14 cm)
Stamped "Paley 1976"
Paley Studio Archive, AG 1976.01

opposite: Parabolic Gate, 1976
Forged, fabricated, and painted steel
96 x 48 x 11 inches
(243.8 x 121.9 x 27.9 cm)
Paley Studio Archive, AG 1976.02

PARABOLIC GATE 1976

PORTAL GATES 1980

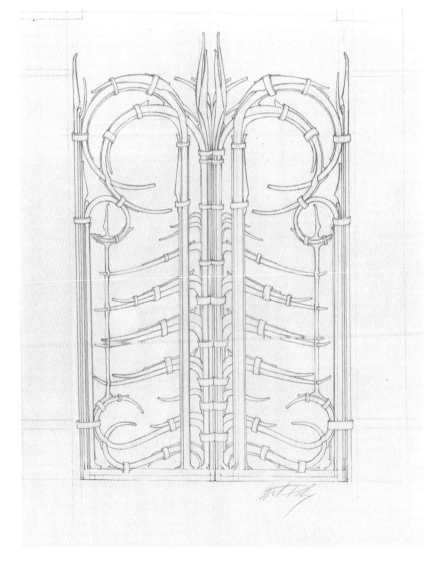

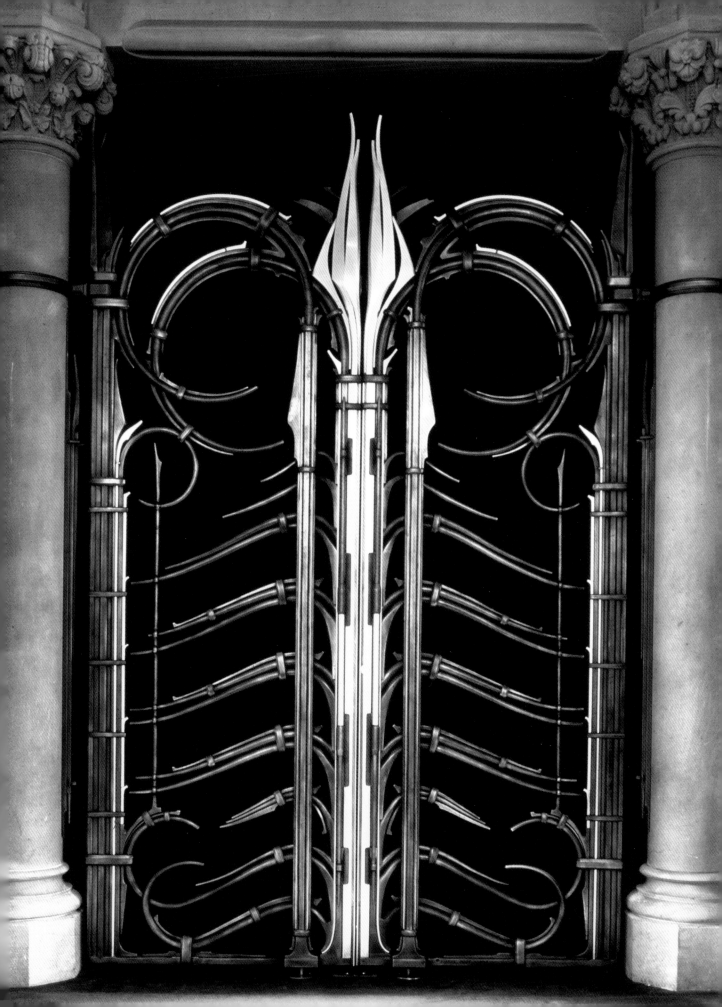

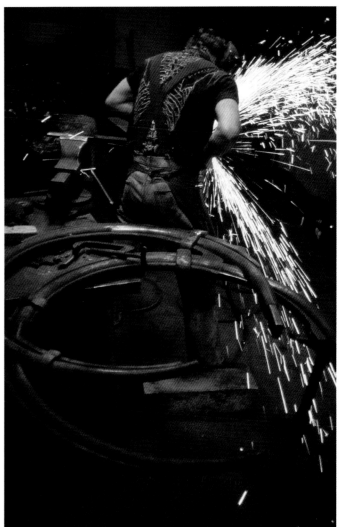
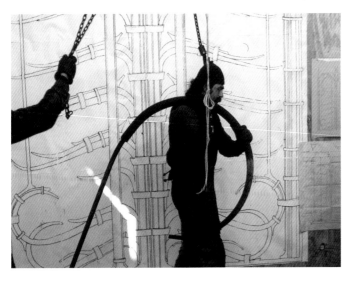

Production of **Portal Gates** (*Albany gates*)
in artist's studio at 1237 East Main Street,
Rochester, New York.
Photo: William Rowley

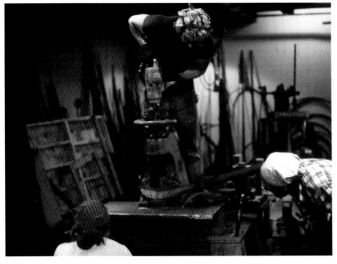

PEDESTRIAN ENTRANCE GATE 1985

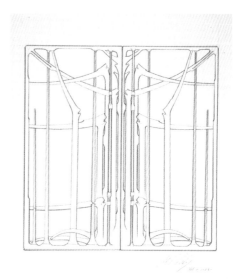

upper: **Virginia Gate,** 1982
Graphite on paper
14 x 16.25 inches (35.6 x 41.3 cm)
Paley Studio Archive, GA 1982.04

lower: **Pedestrian Entrance Gate,** 1985
Forged and fabricated mild steel
8 x 8 feet (2.44 x 2.44 m)
Architects: Hardy, Holzman & Pfeiffer,
New York, New York
Virginia Museum of Fine Arts,
Richmond, Virginia
Paley Studio Archive, AG 1985.01
Photo: Paley Studios

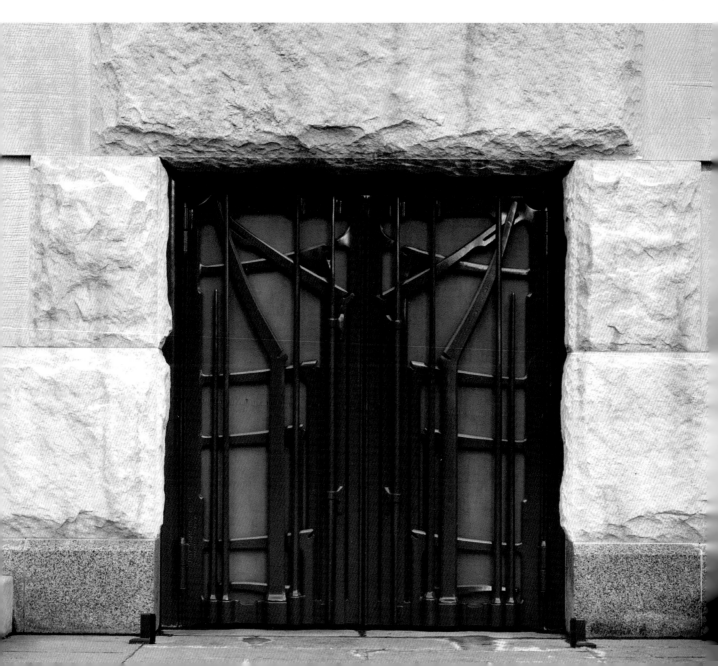

GATE SECTION FOR
CENTRAL PARK ZOO 1987

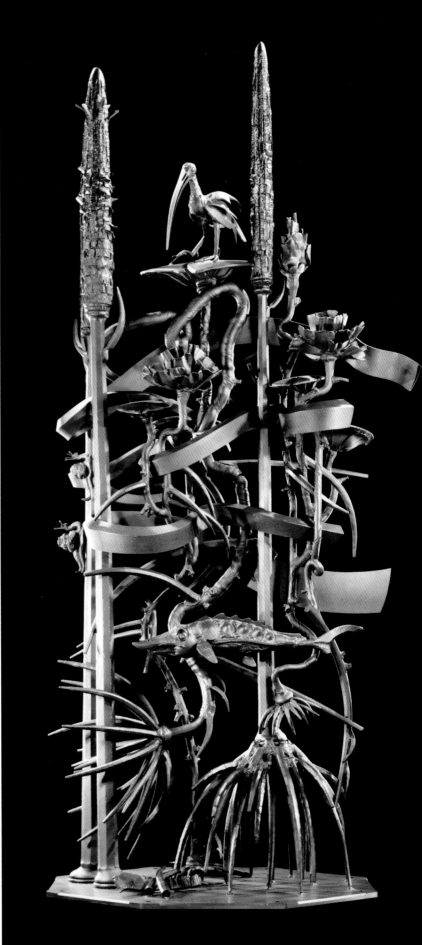

left: Final Proposal for Central
Park Zoo Gate, 1985
Graphite on board
19.75 x 8.75 inches (48.26 x 21.59 cm)
Paley Studio Archive, GA 1985.01

right: Gate Section for Central Park Zoo, 1987
Forged and fabricated Cor-Ten steel with gold leaf
168 x 75 x 66 inches (427 x 190.5 x 168 cm)
Paley Studio Archive, AG 1987.01

SYNERGY 1987

upper: **Synergy** (*Philly Archway presentation drawings*), 1986
Graphite on paper
each: 59.25 x 45.75 inches
(150.5 x 116.2 cm)
Private Collection
Paley Studio Archive: AF 1986.02 *(left);*
AF 1986.03 *(right)*

lower: **Synergy**, 1987
Formed, fabricated, and polychromed
mild steel
25 x 60 x 6 feet (6.11 x 18.29x 1.83 m)
Commissioned by Redevelopment Authority
of the City of Philadelphia for Museum
Towers, Philadelphia, Pennsylvania
Paley Studio Archive, SS 1987.02
Photo: Tom Crane

opposite: Production work on **Synergy** at
North Washington Street Studio, Rochester,
New York (Paley, lower center), 1987.

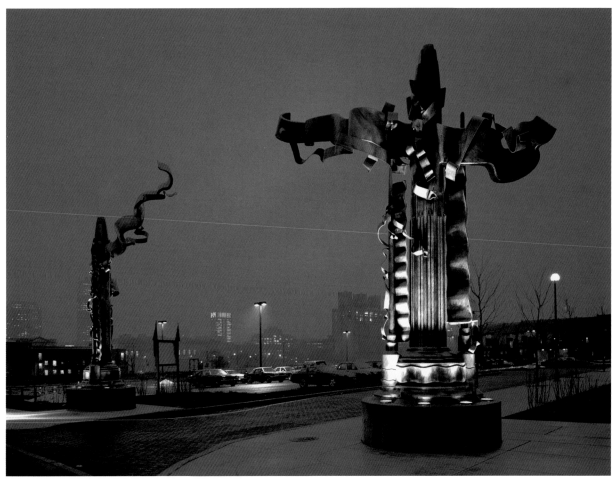

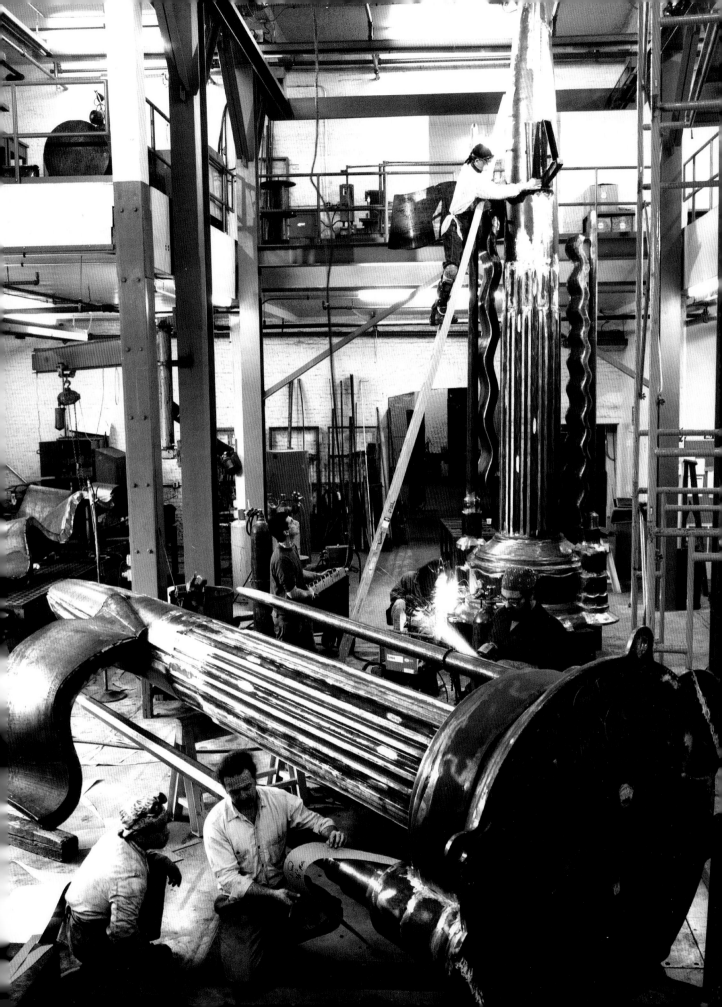

STAIRWAY SCULPTURES 1987

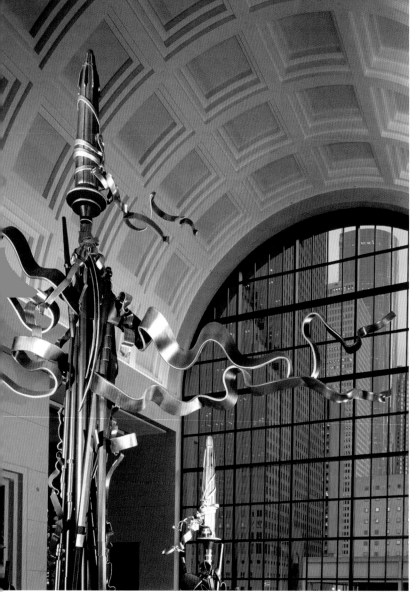

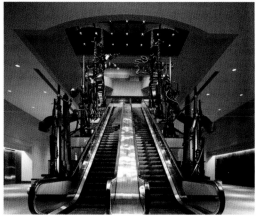

Stairway Sculptures
Formed, fabricated, and painted steel
Eight sculptures vary in height: 15 to 30.5 feet;
highest: 30.5 x 22 x 5 feet (9.30 x 6.71 x 1.52 m)
Wortham Center for the Performing Arts,
Houston, Texas
Paley Studio Archive: AM 1987.01a
Photos: Paul Hester

left: Detail of **Stairway Sculptures**, 1987

upper right: **Wortham Theatre Stairway
Sculpture** (Proposal Drawing), 1985
Graphite on paper
12 x 16 inches (30.5 x 40.6 cm)
Paley Studio Archive, SCU 1985.04.01

lower right: View of
Stairway Sculptures
from base of escalator

opposite: View of **Stairway Sculptures**
from top of escalator

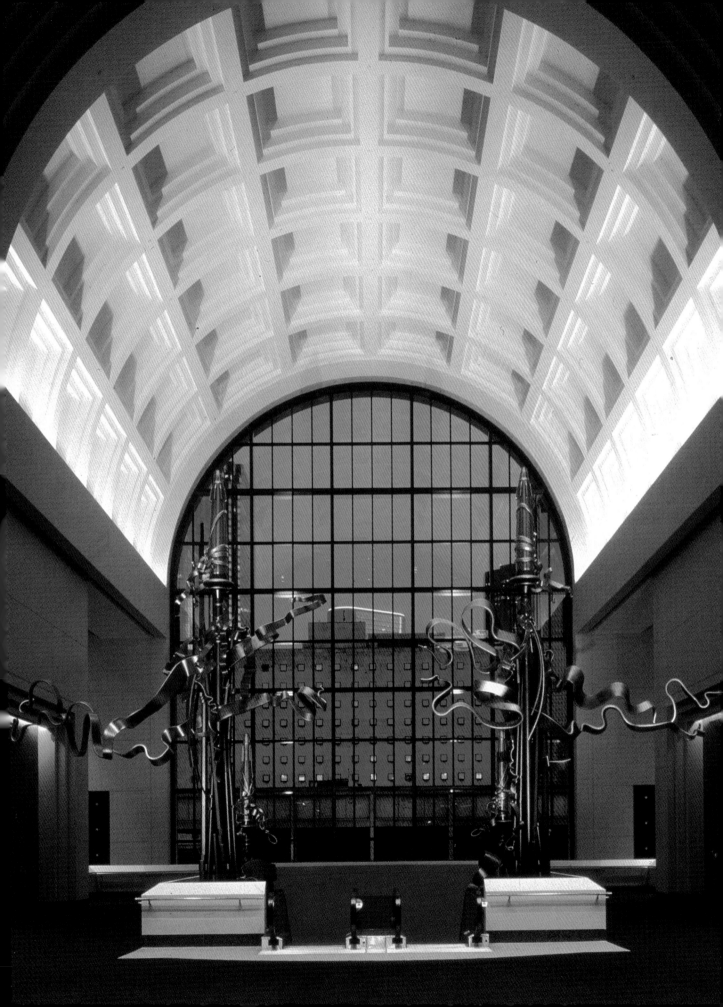

GATE PROPOSAL 1988

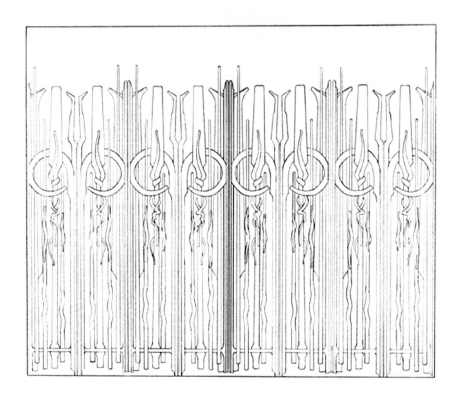

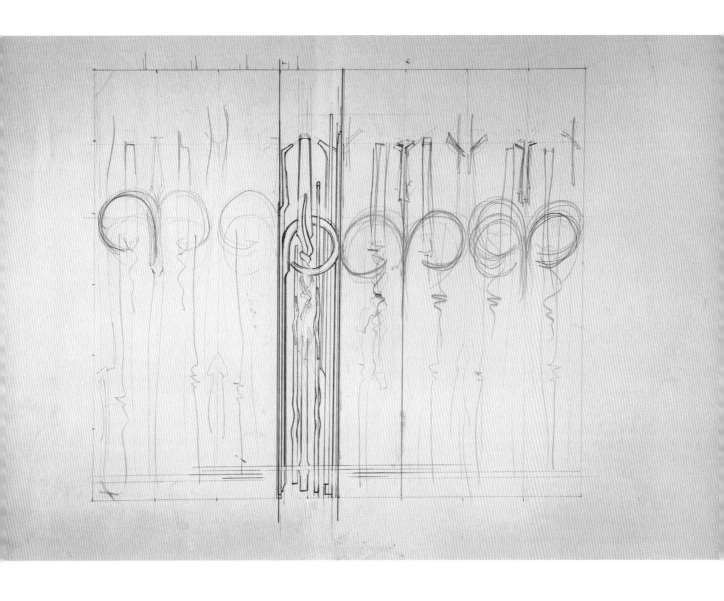

Drawings are graphite on paper

opposite upper: **Proposal #2 for Memorial
Gate, Ackland Art Museum, University of
North Carolina at Chapel Hill,** 1988
23 x 29 inches (58 x 74 cm)
Paley Studio Archive, GA.1988.02.01

opposite lower: **Proposal #1 for Memorial
Gate, Ackland Art Museum, University of
North Carolina at Chapel Hill,** 1988
23 x 29 inches (58 x 74 cm)
Paley Studio Archive, GA.1988.01.01

Gate, 1988
paper: 18 x 24 inches (45.7 x 61cm);
image: 13 x 14 inches (33 x 35.6 cm)
Paley Studio Archive, GA 1988.02.02

FISHER GATES 1990

Drawings are graphite on paper

upper: **Fisher Rose Gate,** 1989
14 x 17.25 inches (35.6 x 35.6 cm)
Paley Studio Archive, GA 1989.02.01

lower left: **Fisher Rose Gate** (detail), 1989
14 x 17 inches (35.6 x 43.2 cm)
Paley Studio Archive, GA 1989.02.02

lower right: **Fisher Rose Gate** (final), 1989
13.5 x 17 inches (34.3 x 43.2 cm)
Paley Studio Archive, GA 1989.03

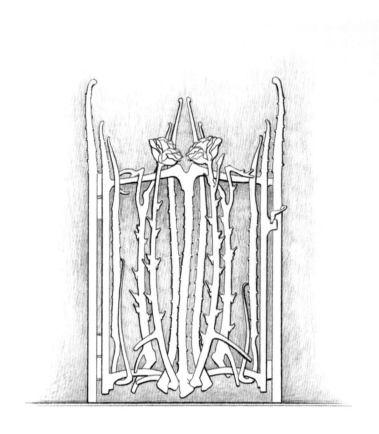

upper: **Fisher Pool Gate**
(first draft), 1989
14 x 17.25 inches (35.6 x 35.6 cm)
Paley Studio Archive, GA 1989.04.01

lower: **Garden Gate 1**, 1990
Forged, fabricated, and painted steel
72 x 48 inches (183 x 123cm)
Private Collection
Photo: Paley Studios

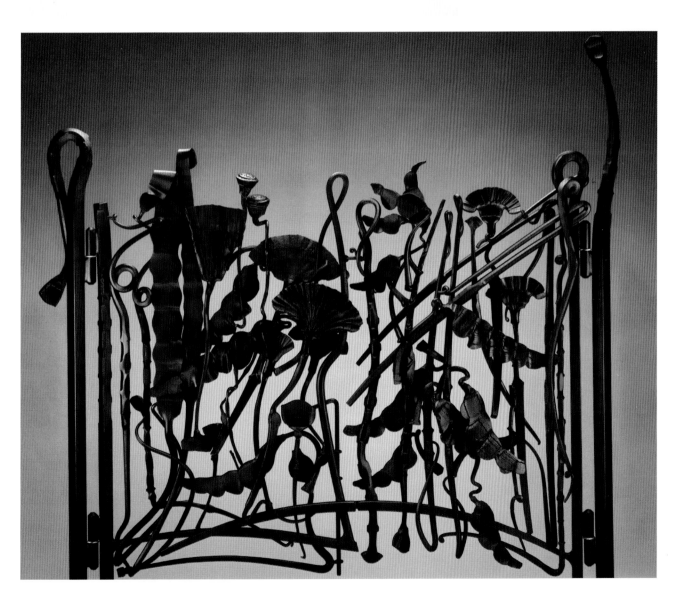

LINDE GATE 1990

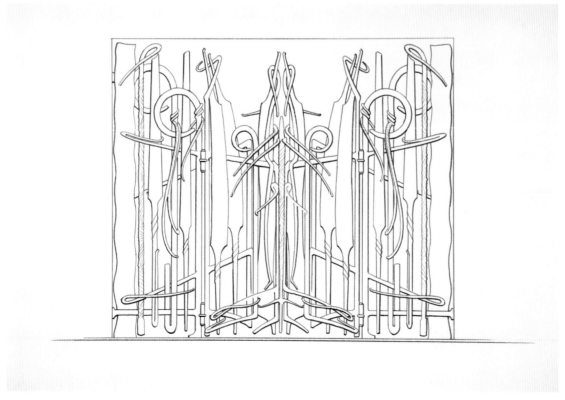

opposite upper: **Linde Gate I,** 1990
Ink on vellum
8.5 x 11 inches (21.6 x 27.9 cm)
Paley Studio Archive, GA 1990.01

opposite lower: **Linde Gate** (final), 1990
Graphite on paper
23 x 29 inches (58.4 x 73.7 cm)
Paley Studio Archive, GA 1990.06

Interior Gate (*Linde Gate*), 1990
Forged and fabricated steel
202 x 135 x 6 inches
(513 x 343 x 15 cm)
Private Collection
Paley Studio Archive, AG 1990.04

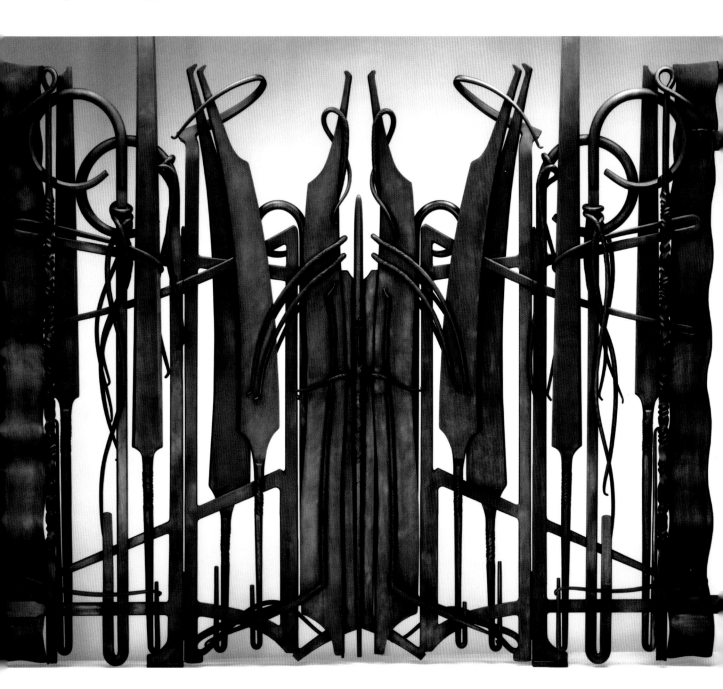

CEREMONIAL PORTAL 1991

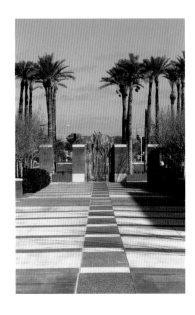

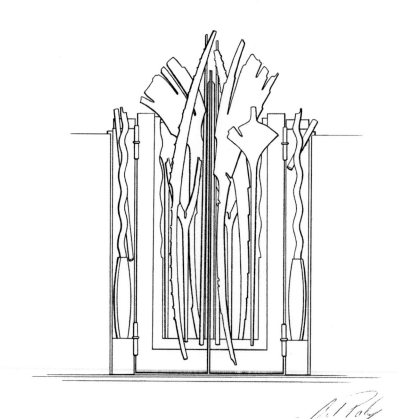

Drawings are graphite on paper
each: 25 x 15 inches (63.5 x 38.1 cm)

upper left: **ASU Ceremonial Gate #2**, 1991
Paley Studio Archive, GA 1991.03.01

upper right: **ASU Ceremonial Gate #3**, 1991
Paley Studio Archive, GA 1991.02.01

lower right: **ASU Ceremonial Gate** (final
drawing), 1991
Paley Studio Archive, GA 1991.01.01

lower left and opposite:
Ceremonial Gates, 1991
Formed, fabricated, and polychromed steel
12 x 8 x 1.5 feet (3.66 X 2.44 X .46 m)
Arizona State University, Tempe, Arizona
Paley Studio Archive, AG 1991.02
Photo: Richard Maack

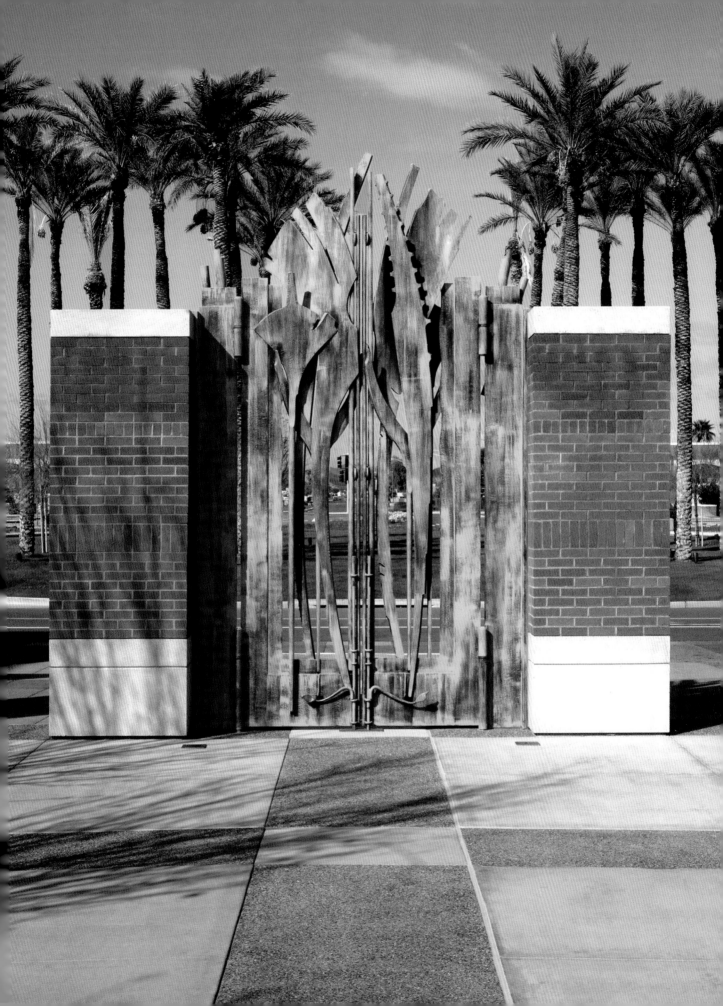

METAMORPHOSIS 1994

upper: **Metamorphosis**, 1992
Graphite on vellum
22 x 41 inches
SCU 1992.05.01

lower: two sections of
Metamorphosis, 1993
Formed, fabricated, and painted steel
Installation: 8.9 x 11.1 x 30.4 feet
(2.7 x 3.3 x 9.2 m)
Commissioned by General Services
Administration for Mitchell Cohen Federal
Courthouse, Camden, New Jersey
Paley Studio Archive, SS 1993.01

opposite: Documentation of rigging
Metamorphosis at the North Washington
studio, Rochester, New York.
(Paley, lower right.)

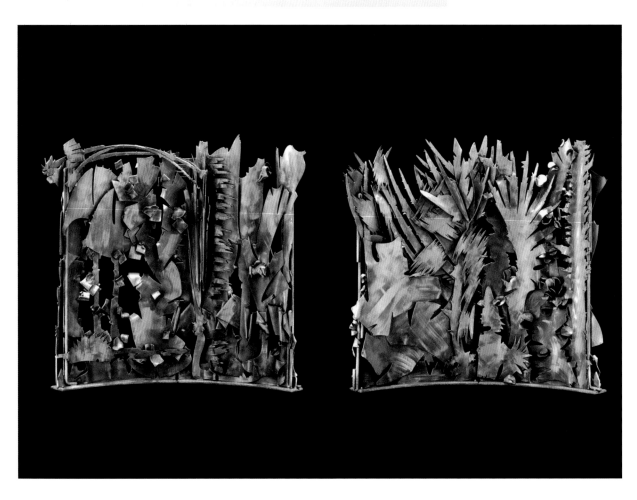

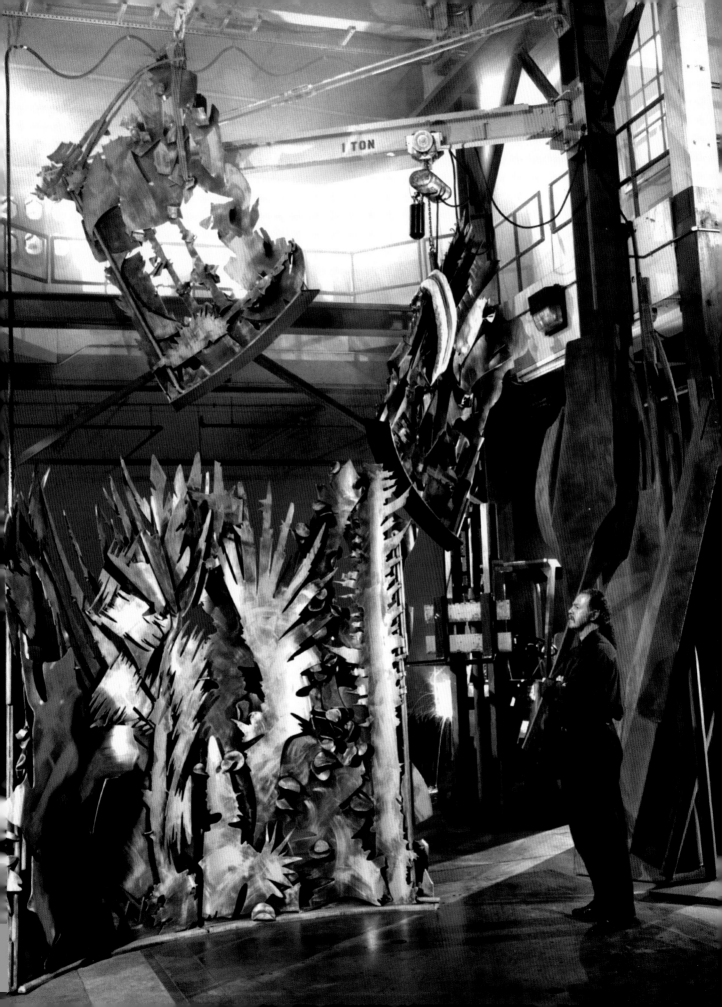

TABERNACLE SCREEN 1994

upper: **Proposal for Tabernacle Screen, Temple Israel, Dayton, Ohio,** 1993
Graphite on paper
22.5 x 28.5 Inches (57 x 72 cm)
Paley Studio Archive,
SCR 1993.01.02

lower: **Study for Dayton Tabernacle Screen, Temple Israel, Dayton, Ohio,** 1984
Graphite on paper
22.5 x 28.5 inches (57.2 x 72.4 cm)
Paley Studio Archive,
SCR 1993.01.03

opposite upper left:
Menorah, 1996
Steel and glass
56.5 x 15 x 73 inches
(143.5 x 38.1 x 185.4 cm)
Paley Studio Archive, AM 1994.02
Photo: Paley Studios

opposite upper right:
Tabernacle Screen, Menorah and **Chandelier** in situ at Temple Israel, Dayton, Ohio.

opposite lower: **Tabernacle Screen,** 1994
Formed, fabricated, and polychromed steel
7.6 feet x 8.6 feet x 4 inches
(2.32 m x 2.62 m x 10 cm)
Temple Israel, Dayton, Ohio
Paley Studio Archive: AM 1994.02

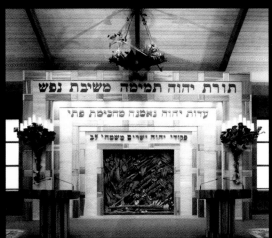

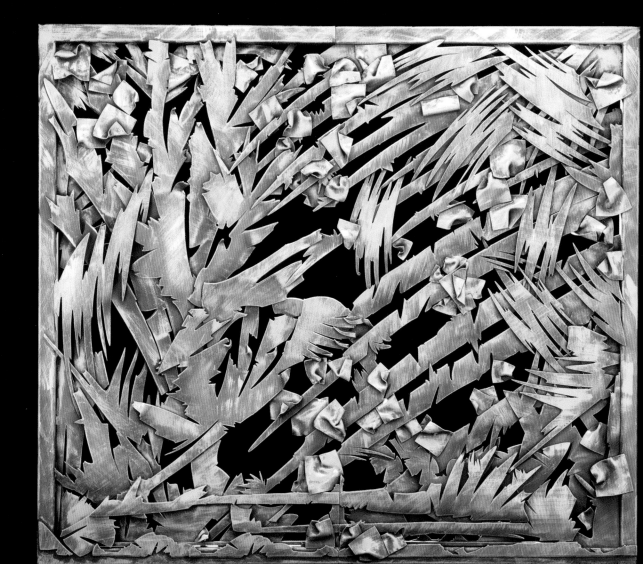

PASSAGE 1995

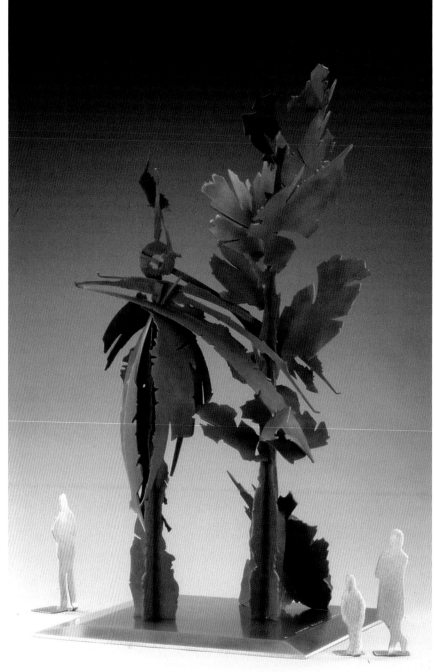

left: **Proposal for Passage, a Sculpture for Asheville, North Carolina,** 1993
Graphite on paper
paper 14 x 11 inches (35.6 x 27.9 cm);
image: 11.5 x 6.5 inches (29.5 x 16.5 cm)
Signed and dated "Albert Paley, 3/5/93"
Paley Studio Archive, SCU 1993.01.01

right: **Maquette for Passage,** 1994
Formed and fabricated Cor-Ten steel
and stainless steel
31.5 x 16.5 x 16.5 inches (80 x 41.9 x 41.9 cm)
Paley Studio Archive, PM 1994.02

opposite: **Passage,** 1995
Formed and fabricated Cor-Ten Steel
37 x 23 x 16 feet (11.28 x 7.01 x 4.88 m)
Commissioned by General Services
Administration for the U.S. Federal Building,
Asheville, North Carolina
Paley Studio Archive, SS 1995.01
Photo: J. Weiland

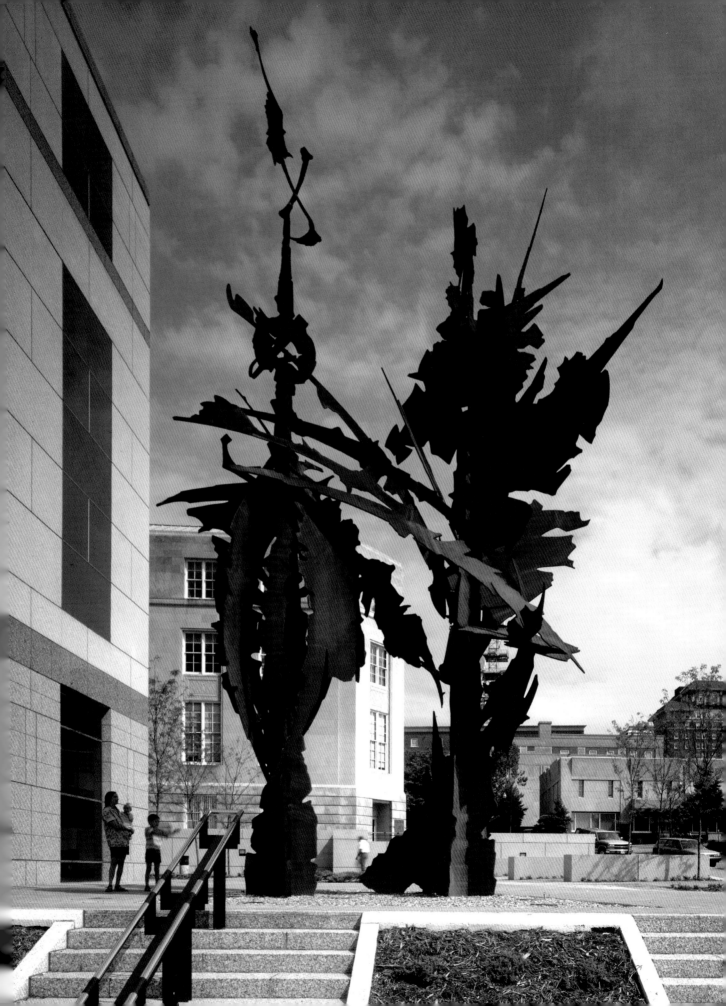

GATES 1997

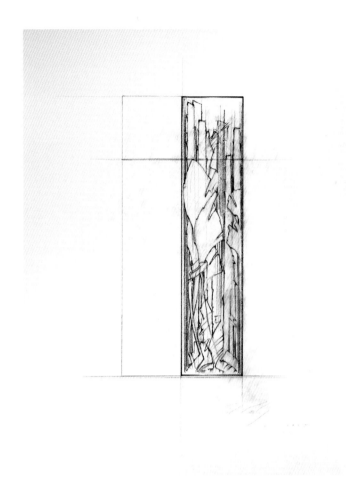

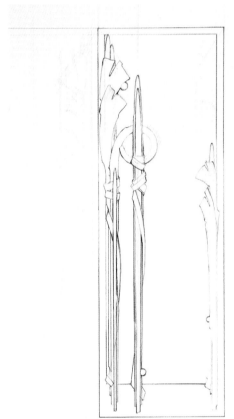

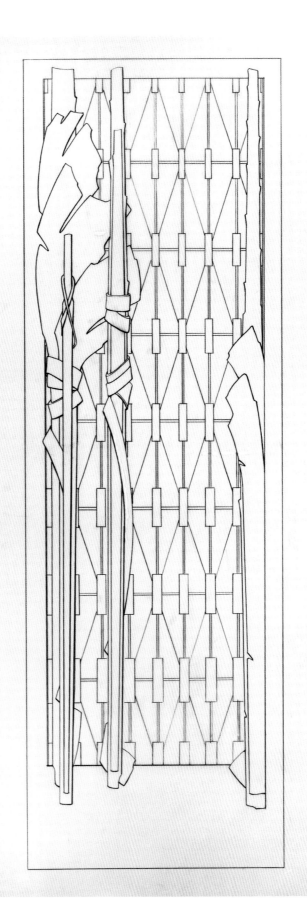

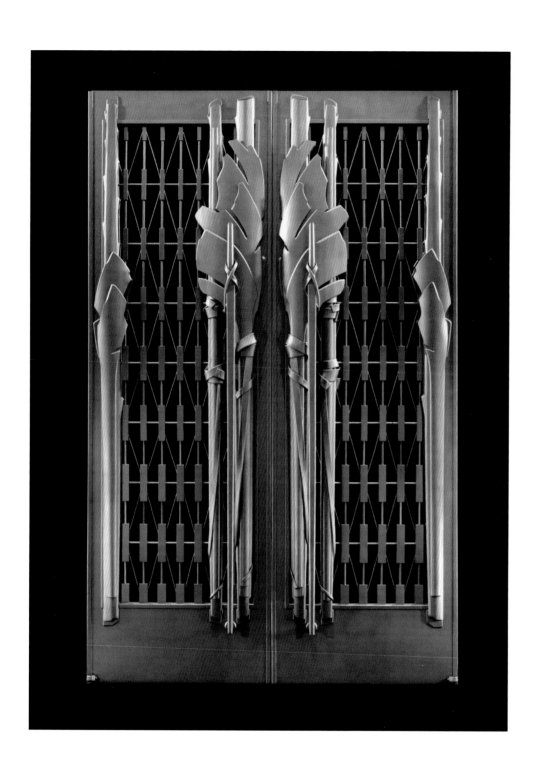

Rotunda Lobby Gates, 1997
Formed and fabricated stainless steel
10.3 x 6.75 feet (3.14 x 2.06 m)
Paley Studio Archive, AM 1997.01.6

opposite: **Rotunda Lobby Gates** in situ at
the Civic Center Courthouse, San Francisco,
California. Photo credit: Paley Studios

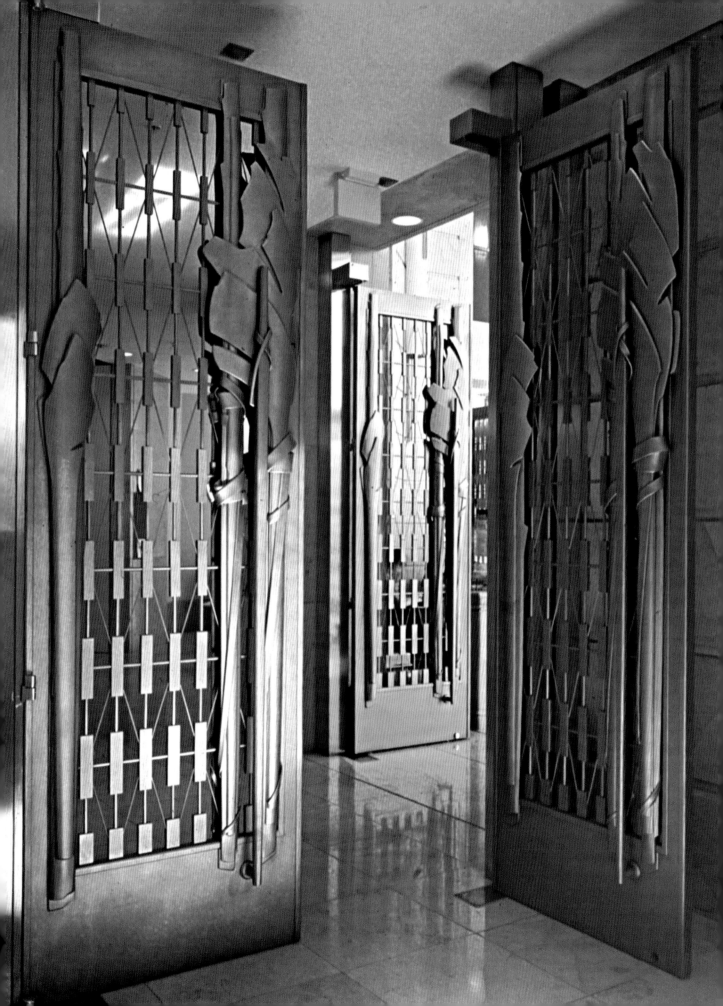

HORIZON 1998

upper: **Horizon Maquette,** 1997
Cor-Ten steel, stainless steel, and bronze
18 x 13.5 x 8 inches (45.7 x 34.5 x 20.3 cm)
Paley Studio Archive, PM 1997.05

lower: **Horizon,** 1998
Formed and fabricated Cor-Ten steel, stainless
steel, bronze with natural patina; water fountain
and lighting features for plaza complex
28 x 37 x 7 feet (8.53 x 11.23 x 2.13 m)
Commissioned for Adobe Systems, Inc.,
Corporate Headquarters, San José, California
Photo: Winston Swift Boyer

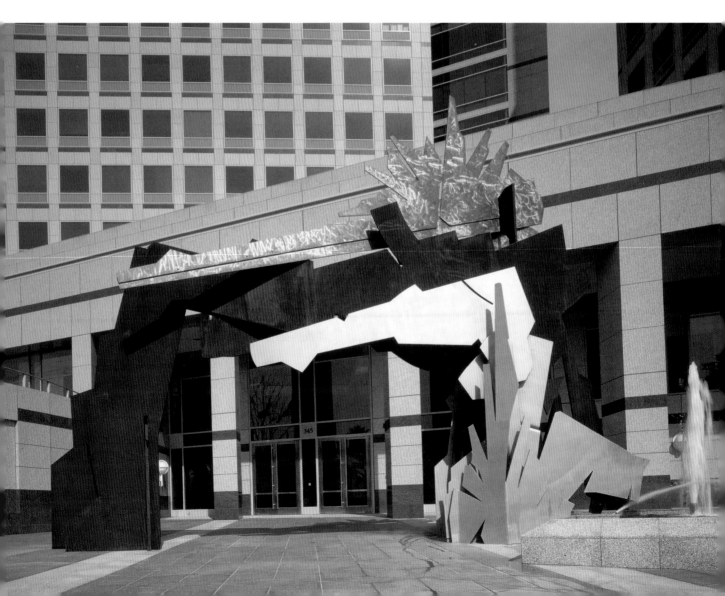

DESERT WILLOW 1998

upper: **Study for Desert Willow,** 1998
Red pencil on paper
framed: 32.5 x 26.5 inches (82.6 x 67.3 cm)
Paley Studio Archive, SCU 1998.01

lower: **Desert Willow Maquette,** 1998
Formed and fabricated carbon steel, stainless
steel, and brass; natural rusted patina
25 x 26 x 11.25 inches (63.5 x 66 x 28.6 cm)
Paley Studio Archive, PM 1998.04

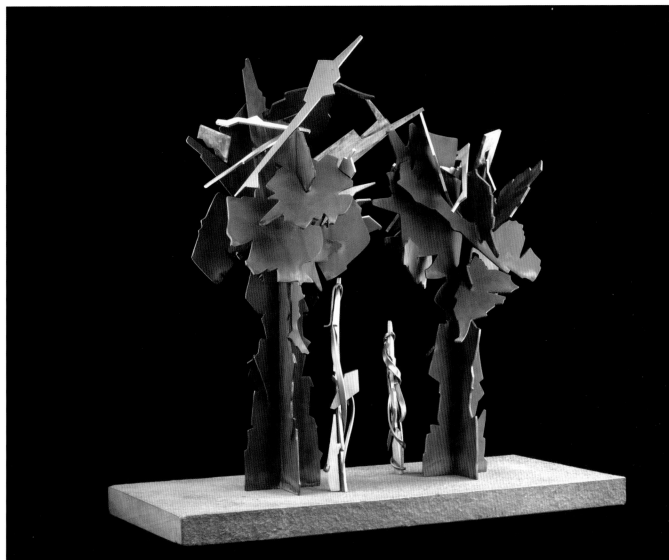

STADIUM ENTRANCE 1999

Drawings are red pencil on paper
each: 32 x 50 inches (81.3 x 127 cm)

upper: **Tallahassee Gate Proposal 1**
(Florida State University, figurative), 1997
Paley Studio Archive, GA 1997.01.01

center: **Tallahassee Gate Proposal 2,** 1997
Paley Studio Archive, GA 1997.01.02

lower: **Tallahassee Gate Proposal 3** (final), 1997
Paley Studio Archive, GA 1997.01.03

opposite: **Stadium Entrance,** 1999
Formed and fabricated steel, stainless
steel and bronze
12.5 x 36 x .5 feet (3.81 x 10.97 x .15 m)
Commissioned for Florida State University,
Tallahassee, Florida
Paley Studio Archive, AG 1999.01

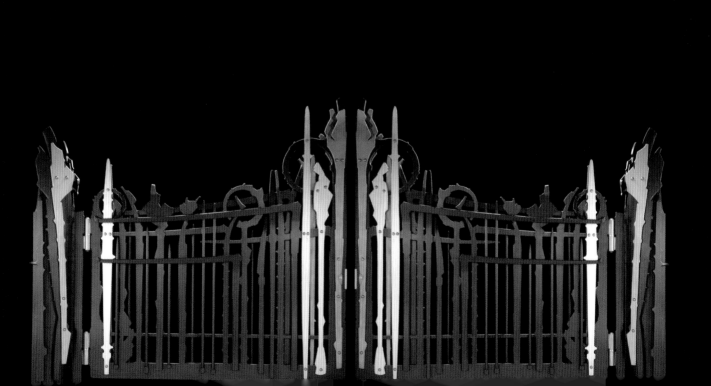

SPLIT VISION—RELIEF 2000

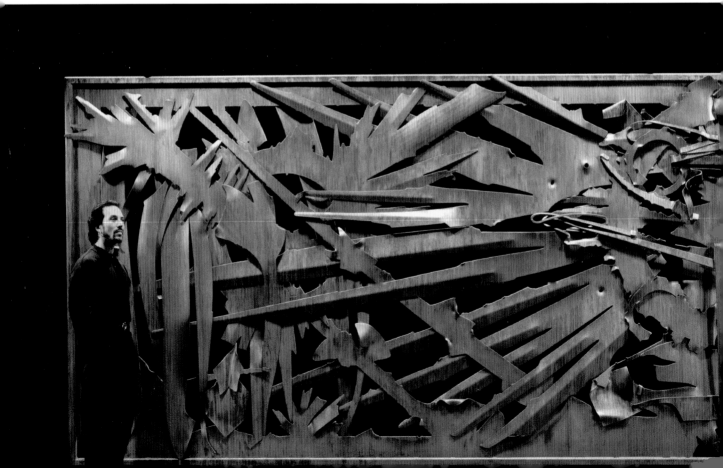

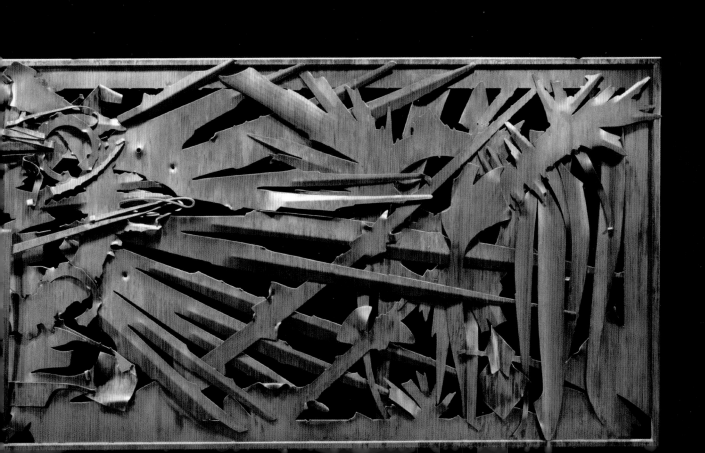

Split Vision, 2000
Red pencil and graphite on paper
19 x 25.5 inches (48.3 x 64.8 cm)
Paley Studio Archive, SCR 1998.01.01

2 . 1 9 9 8

PORTAL GATES 2000

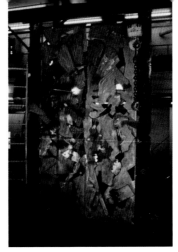
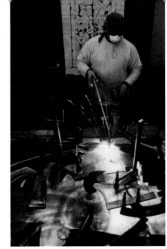

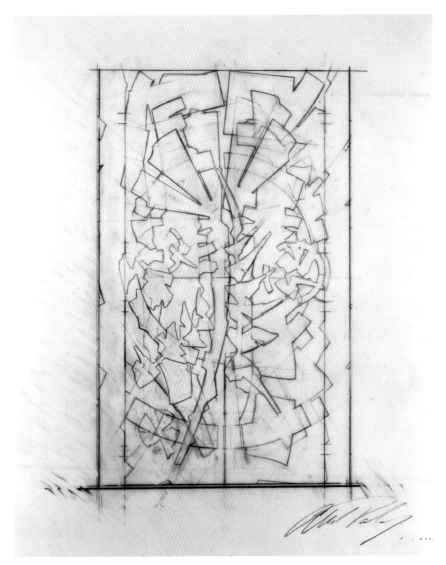

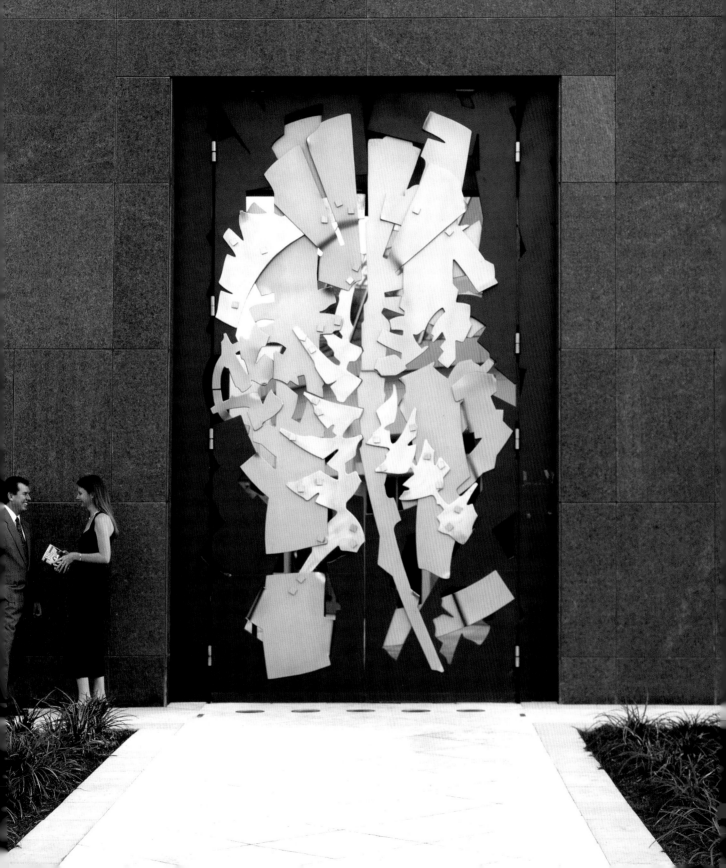

NAPLES MUSEUM *of* ART

CONSTELLATION 2002

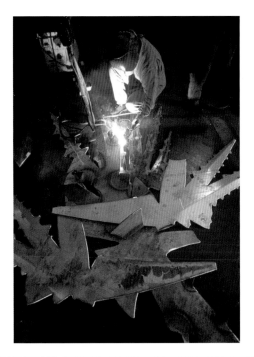

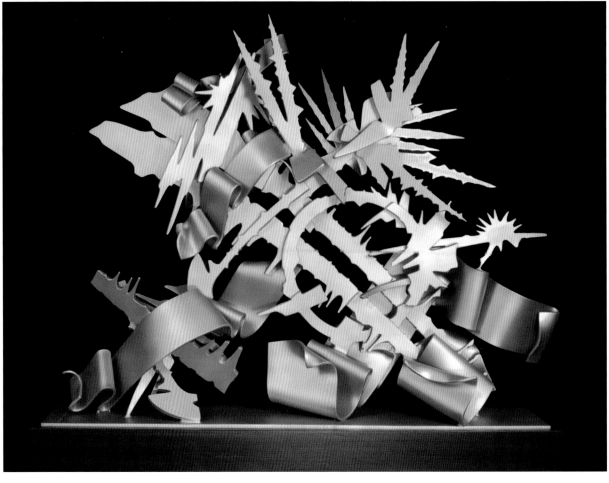

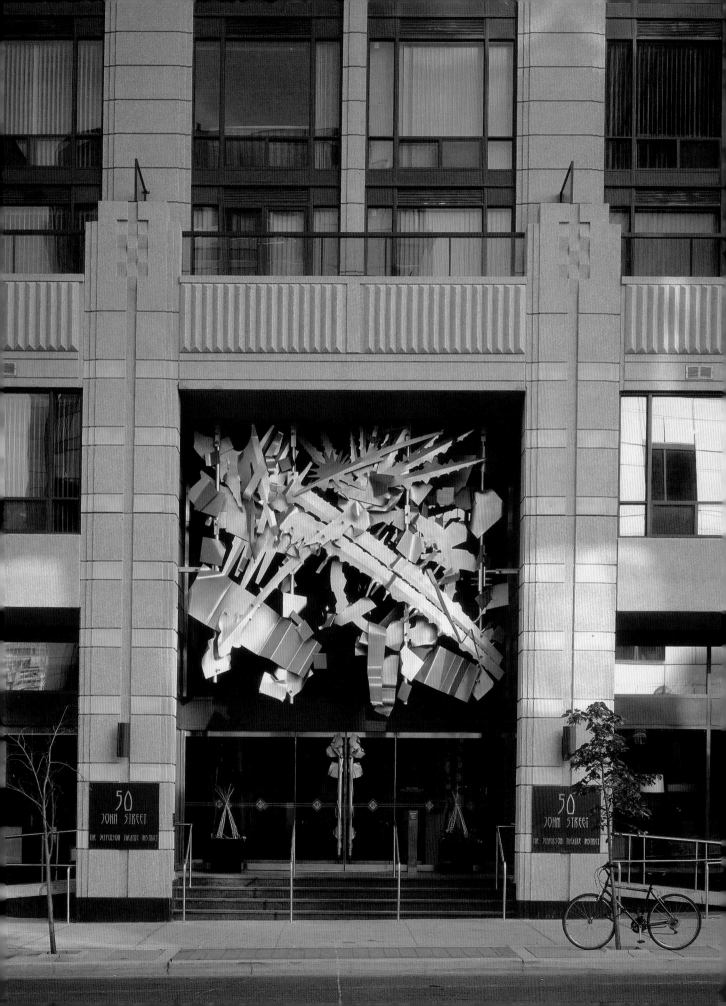

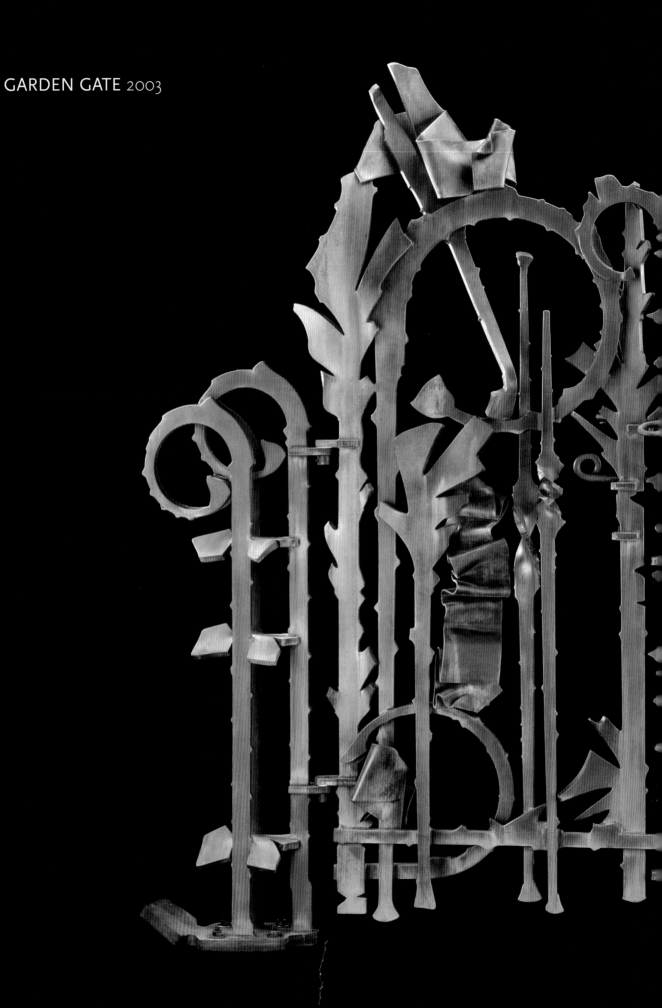

GARDEN GATE 2003

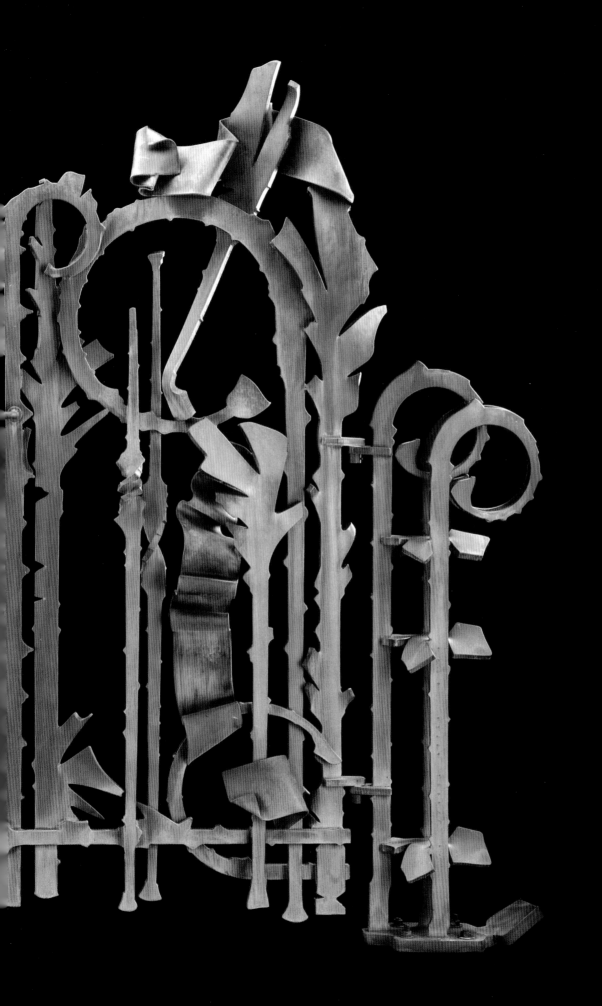

DUNCAN GATE 2003

pp. 102–103: Garden Gate, 2003
Formed and fabricated Cor-Ten steel and mild steel
74.75 x 104 x 30 inches
(189.2 x 264.2 x 76.2 cm)
Paley Studio Archive, AG 2002.01

Duncan Gate Design, 2002
Red pencil on paper
11 x 14 inches (27.9 x 35.6 cm)
Paley Studio Archive, GA 2002.02

opposite: Duncan Gate, 2003
Forged and fabricated mild steel
143 x 205 x 6 inches (363.2 x 520.7 x 15.2 cm)
Paley Studio Archive, AG 2003.02

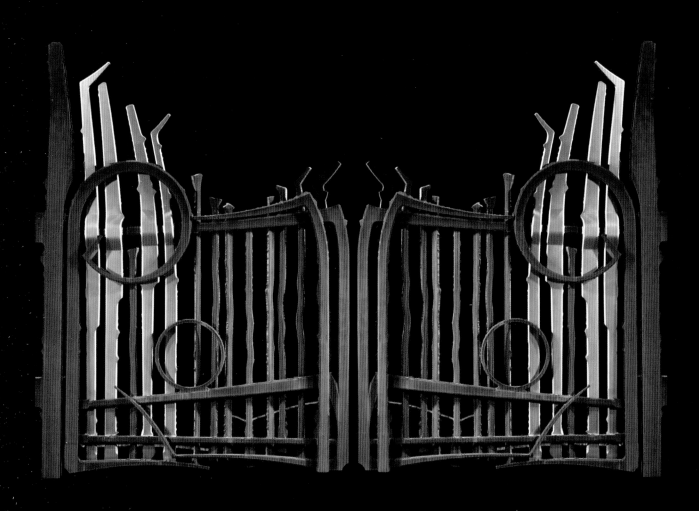

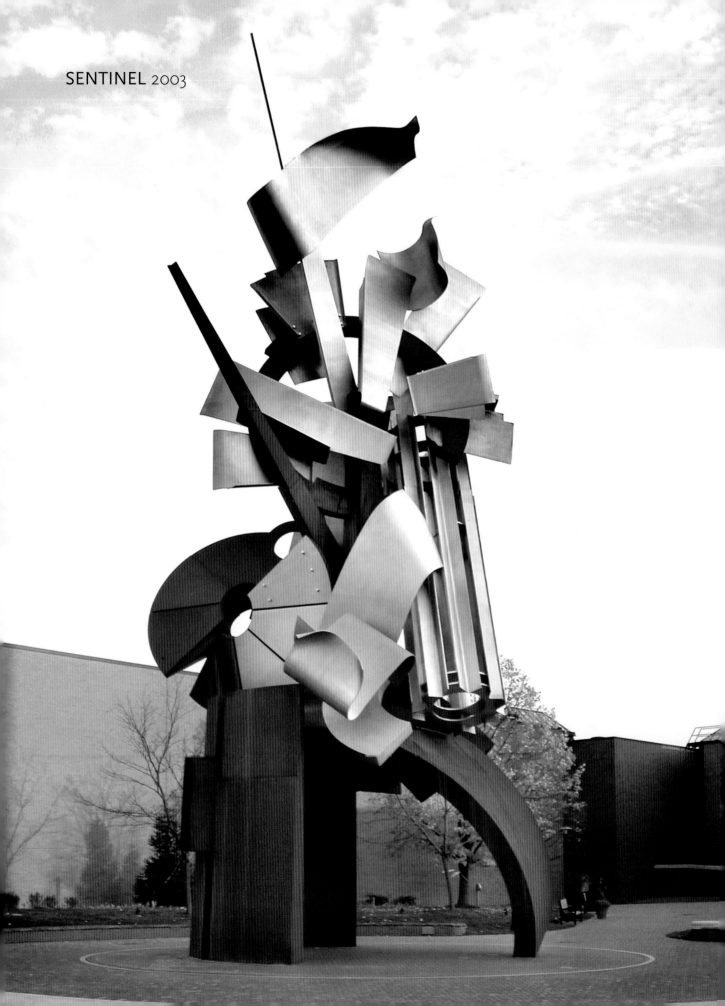

SENTINEL 2003

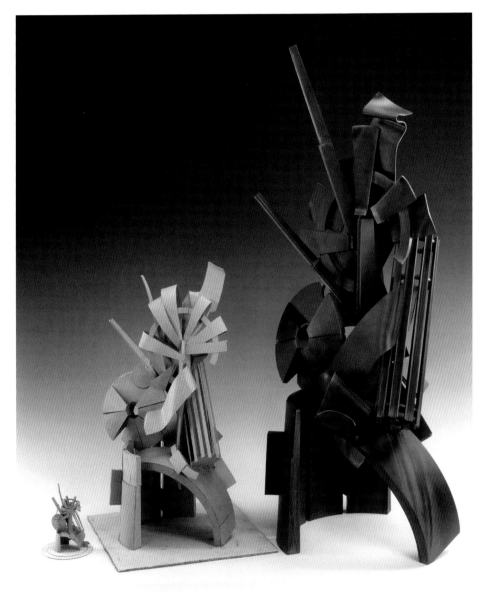

opposite: **Sentinel,** 2003
Formed and fabricated Cor-Ten and
stainless steel and bronze
73 x 30 (diam.) feet (22.25 x 9.14 m)
Rochester Institute of Technology,
Rochester, New York
Paley Studio Archive, SS 2003.01

upper left: Albert Paley assembles
a working model of *Sentinel*

upper center: The artist places
Sentinel within a landscaping plan
for the pedestrian plaza

upper right: The assemblage of a
full-scale, plywood mock-up for the
final metal patterns of *Sentinel*

lower: **Sentinel** (three developmental
models), 2001
(left) cardboard
6.75 x 17 (diam.) inches (17.1 x 43.2 cm),
Paley Studio Archive, PM 2001.03;
(center) cardboard
34 x 29 (diam.) inches (86.4 x 73.7 cm),
Paley Studio Archive, PM 2001.02;
(right) formed and fabricated steel
51 x 32 (diam.) inches (129.5 x 81.3
cm),
Paley Studio Archive, PM 2001.01

EPOCH 2004

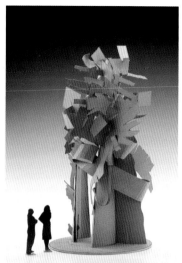

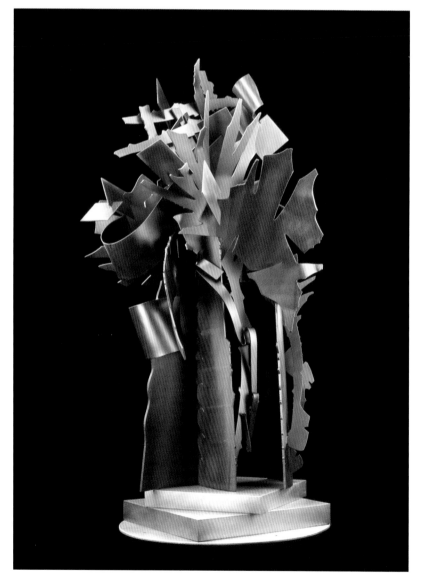

upper left: **Epoch** (proposal drawing), 5.1.2001
Red pencil on paper
paper: 21 x 29 inches (53.2 x 73.7 cm)
framed: 35.5 x 26.5 inches (90.2 x 67.3 cm)
Paley Studio Archive, SCU 2001.1

upper right: **Epoch** (development model), 2002
Cardboard and red pencil
23 x 12 (diam.) inches (58.42 x 30.48 cm)

lower: **Epoch,** 2004
Formed and fabricated A-36 mild steel
and stainless steel
76 x 40 x 32 inches (193 x 101.6 x 81.3 cm)
Signed "Albert Paley 2004" in base
Paley Studio Archive, SF 2005.01

opposite: **Epoch,** 2004
Formed and fabricated mild steel with
polychrome finish
24 x 12 x 10.58 feet (7.32 x 3.66 x 3.22 m)
Commissioned by DC Commission
on the Arts and Humanities, Washington, D.C.
Paley Studio Archive, SS 2004.01
Photo: Paley Studios

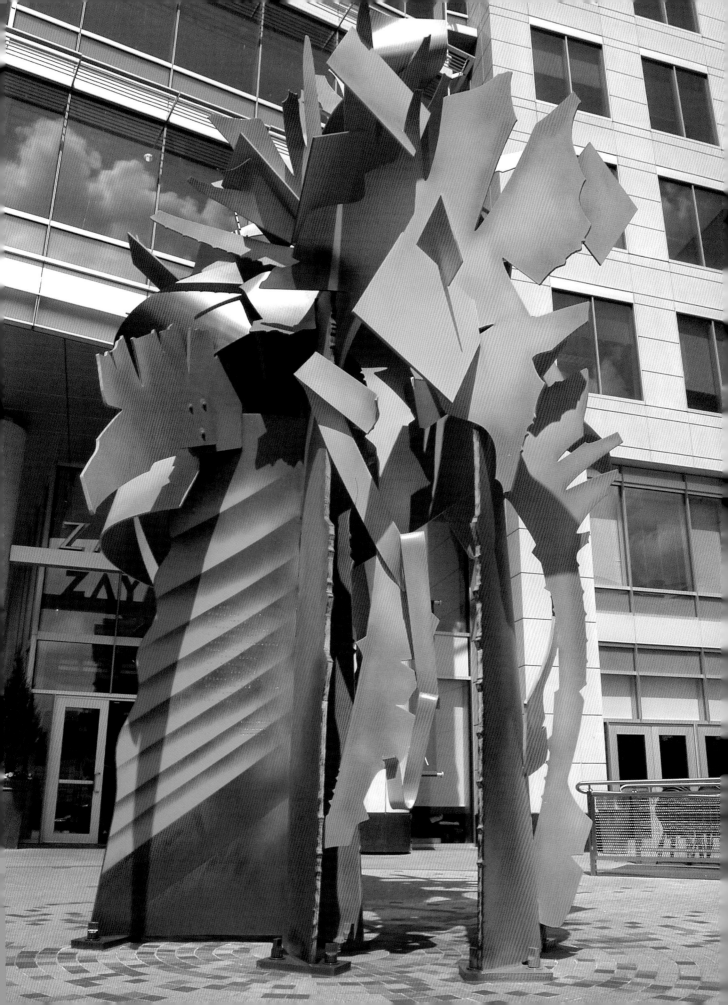

ENTRANCE DOORS 2004

Four Concept Studies for
Entrance Doors, 2004
Red pencil and graphite on paper
22 x 28 inches (55.9 x 71.1 cm)
Paley Studio Archive, AO 2004.01

opposite: **Entrance Doors,** 2004
Formed and fabricated steel and glass
7 x 6.5 feet x 7 inches (2.13 x 1.98 x .18 m)
Private Collection, Naples, Florida
Paley Studio Archive, AG 2004.02

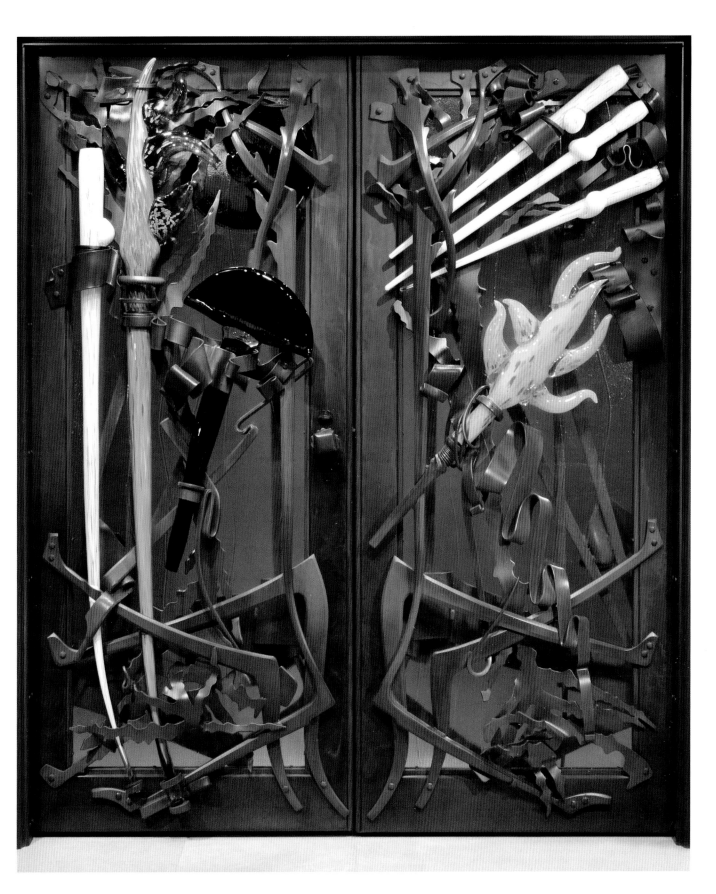

KOHL GATE 2004

upper: **Proposal for Cleveland Botanical Garden, Ohio** (*Kohl Gate*), 2003
Red pencil on transparent film
framed: 27 x 33.5 inches (68.6 x 85.1 cm)
Paley Studio Archive,
GA 2003.03.02

lower: **Flora Study for the Cleveland Botanical Garden, Ohio**, 2003
Red pencil and black ink on
transparent film
9.5 x 8.25 inches (24.1 x 20.9 cm)
Paley Studio Archive, GA 2003.03.03

opposite upper: **Cleveland Botanical Garden Gate Model** (post installation model of *Kohl Gate*) 2005
Formed and fabricated A-36
steel with copper with natural rust patina
Production work on *Kohl Gate*
at North Washington Street Studio,
Rochester, New York.
Paley Studio Archive, SF 2006.24

opposite lower: Detail of **Kohl Gate**

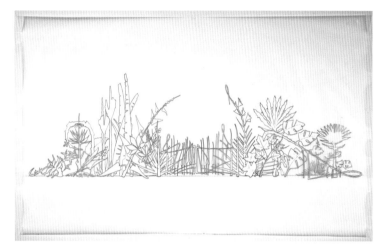

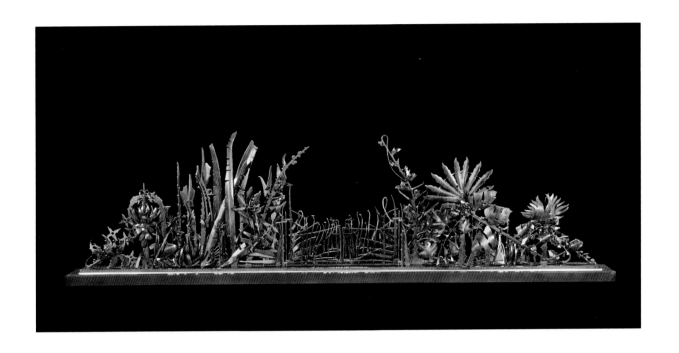

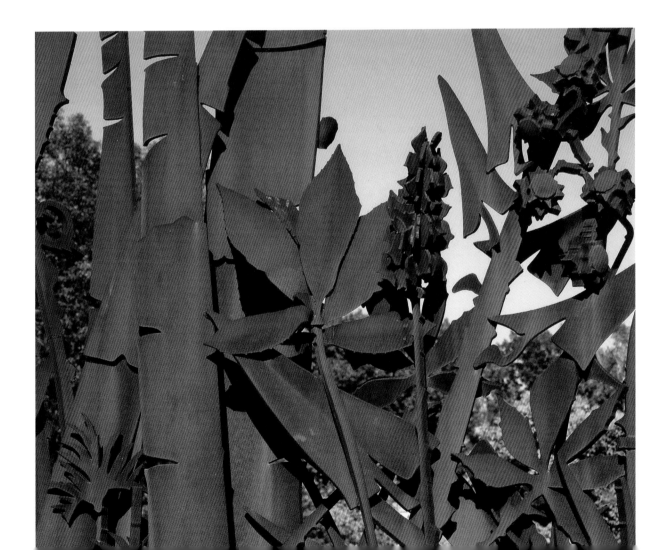

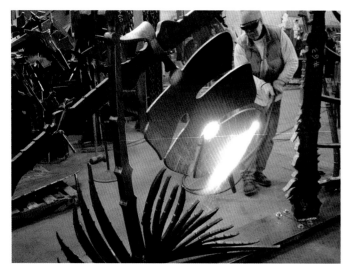

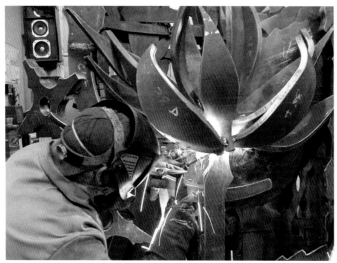

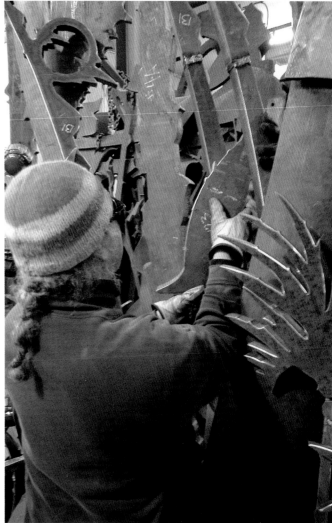

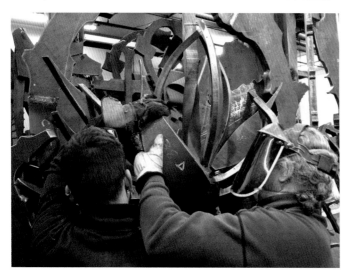

above and opposite:
Production work on *Kohl Gate* at
North Washington Street Studio,
Rochester, New York, 2004
(Paley, upper left and right, and lower left)

pp. 116 – 117: **Kohl Gate,** 2004
Formed and fabricated Cor-Ten steel
14.8 x 55.25 x 3.2 feet (4.51 x 16.25 x .98 m)
Architect: Graham Gund,
East Cambridge, Massachusetts

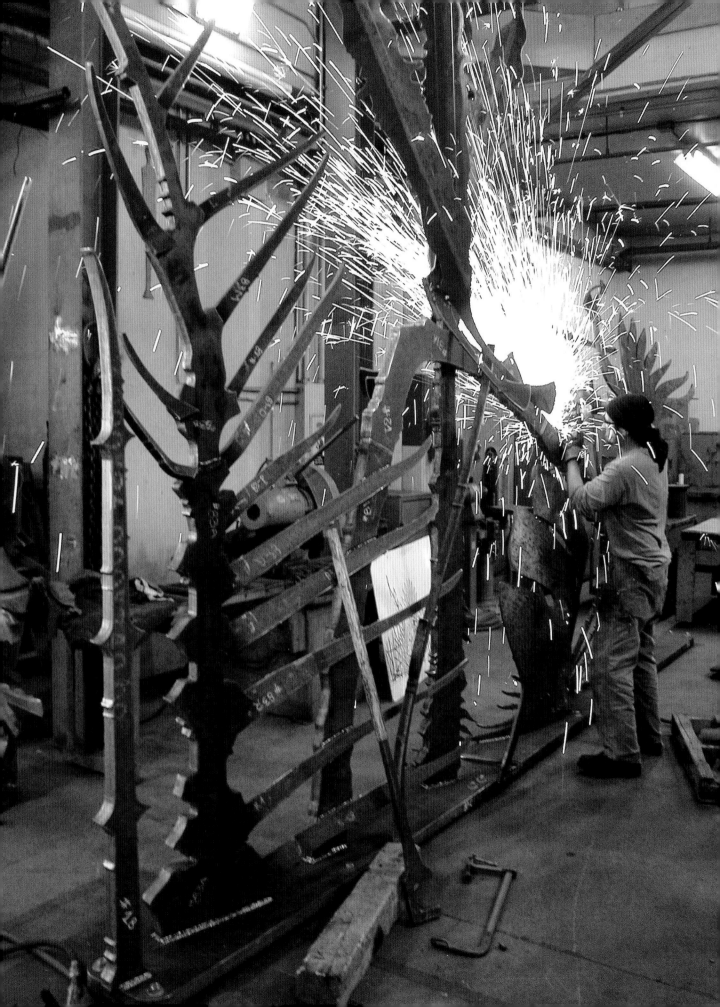

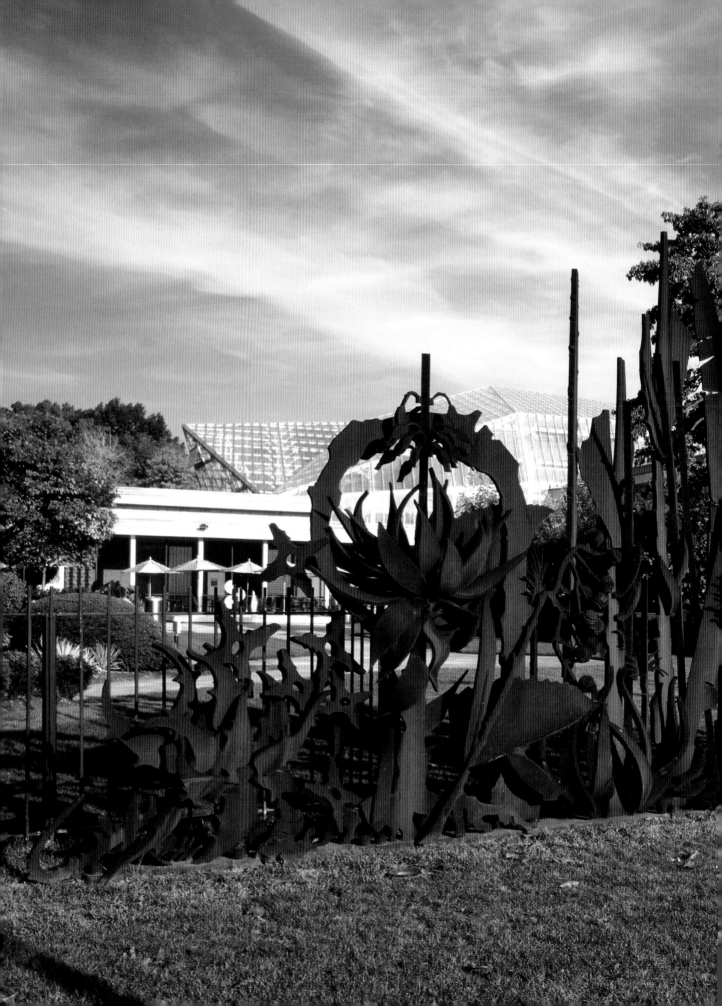

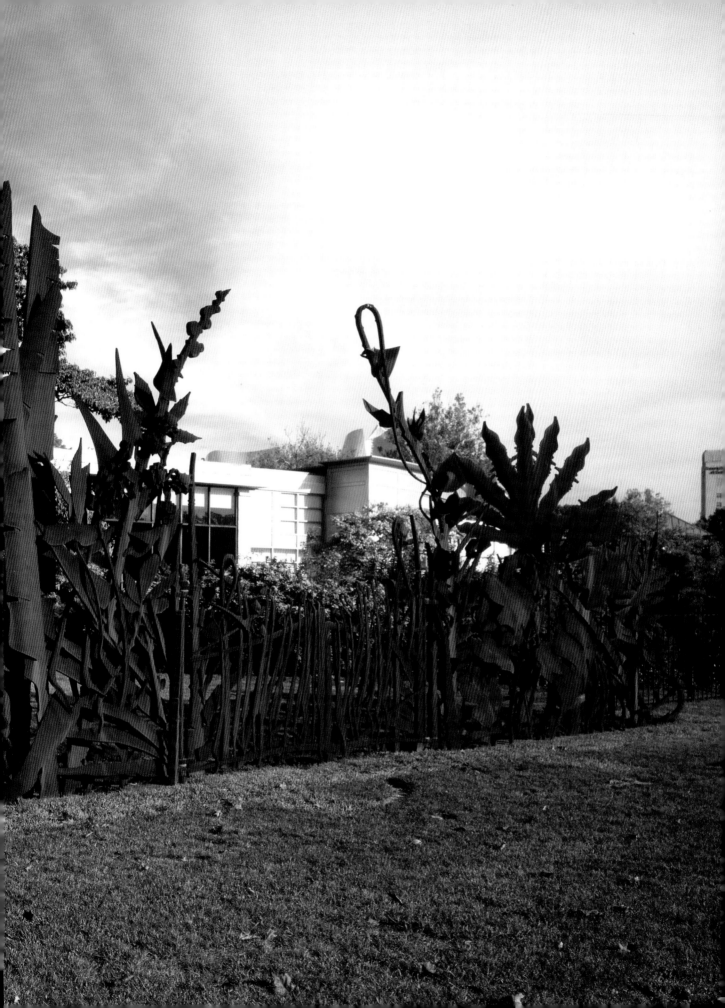

PORTAL 2005

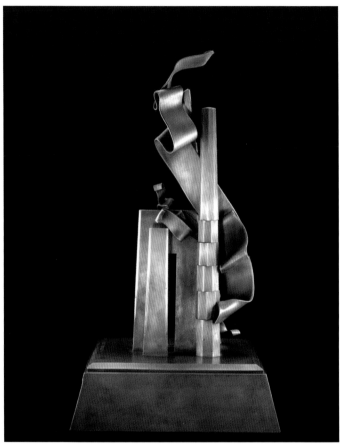

left: **Proposal for a Plaza Sculpture, Boston, Massachusetts,** 1989
Graphite on paper
34 x 25 inches (86.3 x 63.5 cm)
Paley Studio Archive, SCU 1989.07.01

right: **Portal** (Proposal maquette for a plaza sculpture, Boston, Massachusetts), 1990
Forged and fabricated stainless steel
with copper plating and natural patina
Stamped "© Albert Paley 1990"
27.75 x 15.13 x 13.5 inches
(70.4 x 38.43 x 34.2 cm)
Paley Studio Archive, PM 1990.02

opposite: (Paley with *Portal,* 2005, at construction site, Rochester, New York)
Portal, 2005
Formed and fabricated A 588 Cor-Ten steel
with naturally rusted patina
30 x 11.8 x 8.5 feet (9.14 x 3.60 x 2.59 m)
Stamped "Albert Paley 2005"
Paley Studio Archive, SF 2005.02

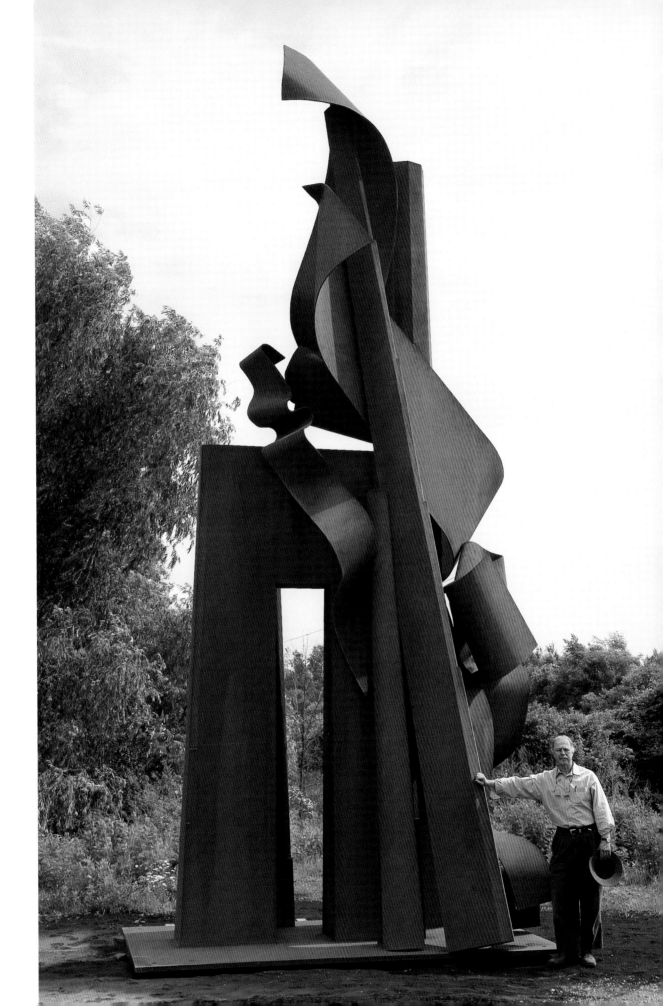

MEMPHIS PORTAL 2005

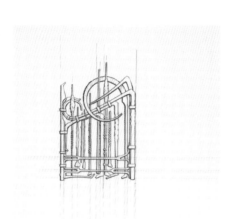

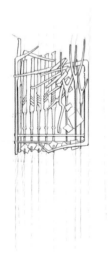

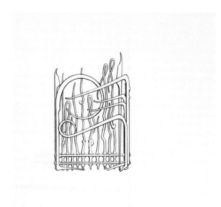

Drawings are red pencil on paper.
each; 24 x 18 inches (60.9 x 45.7 cm)

upper left: Gate Proposal # 1
– Memphis Portal, 2004
Paley Studio Archive, GA 2004.01.02

upper right: Gate Proposal # 3
– Memphis Portal, 2004
Paley Studio Archive, GA 2004.01.04

lower left: Gate Proposal # 4
– Memphis Portal, 2004
Paley Studio Archive, GA 2004.01.05

lower right: Gate Proposal # 5
– Memphis Portal, 2004
Paley Studio Archive, GA 2004.01.06

opposite: Gate Proposal # 2
– Memphis Portal, 2004
Paley Studio Archive, GA 2004.01.03

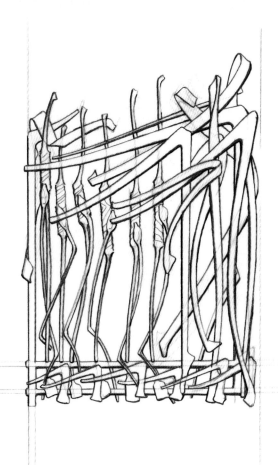

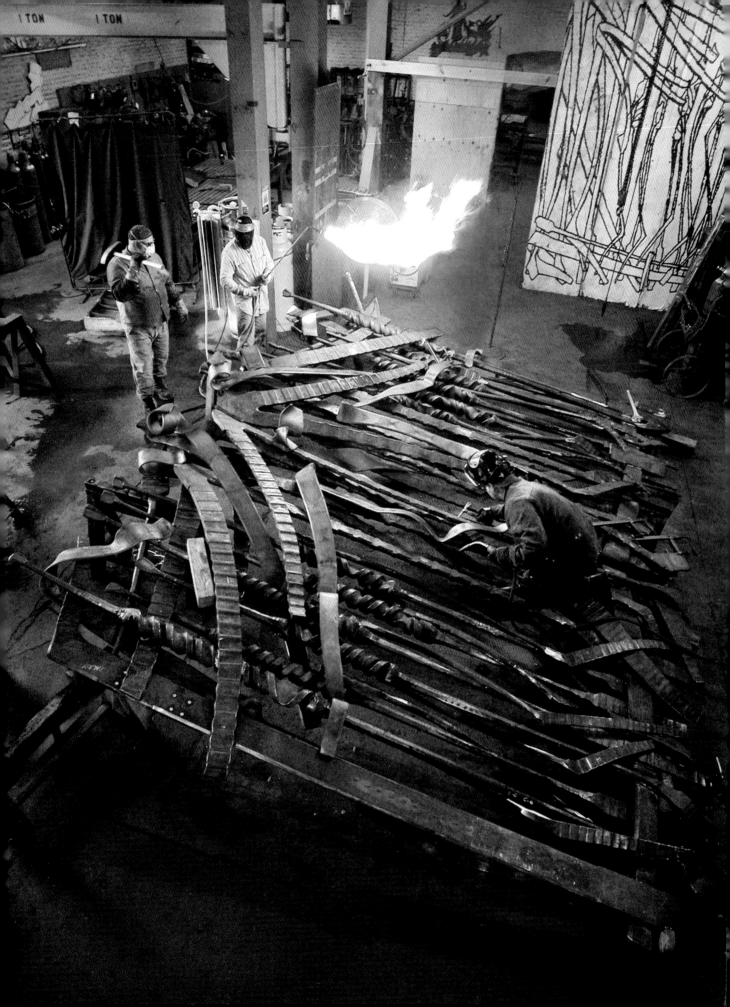

opposite: Fabrication of
Memphis Portal at North Washington
Studio, Rochester, New York.

Memphis Portal, 2005
Forged and painted steel
15.25 x 1.5 x 14.5 feet
(4.65 x .46 x 4.42 m)
Memphis Museum of Art,
Memphis, Tennessee
Paley Studio Archive, AG 2005.01
(Paley, right)

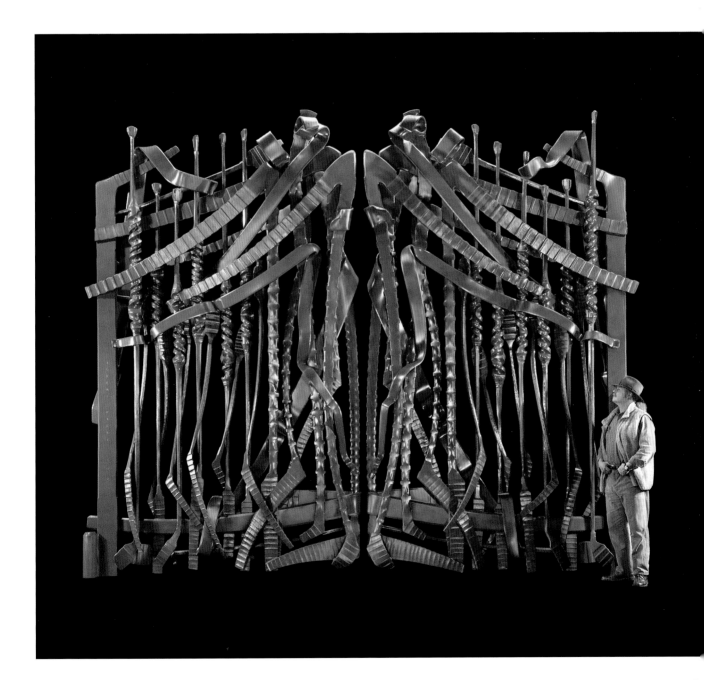

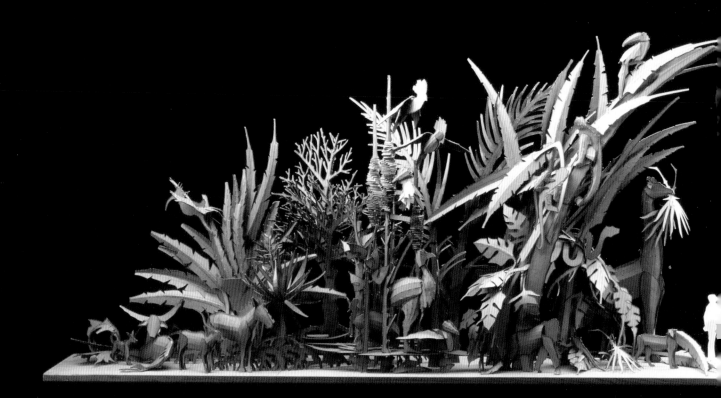

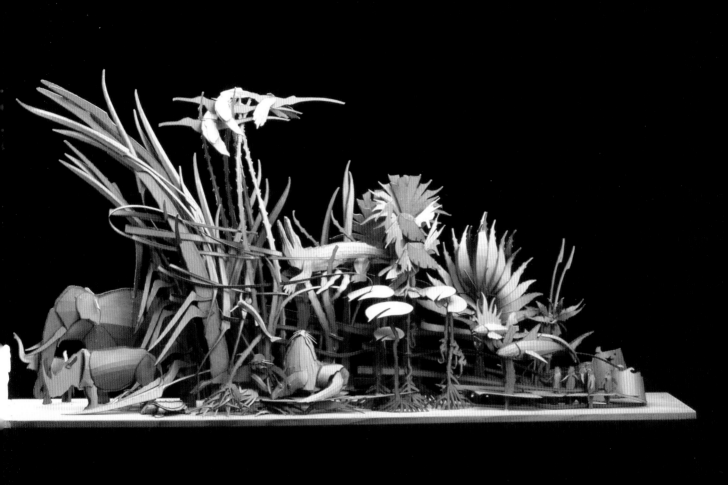

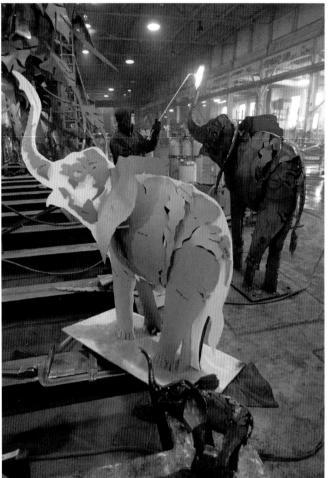

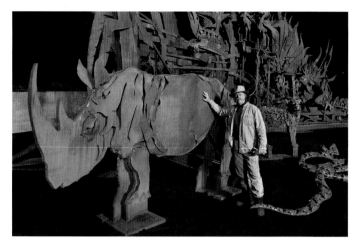

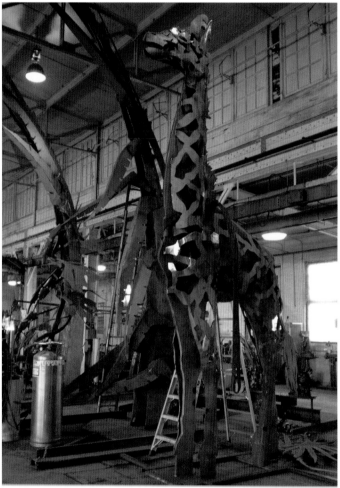

pp. 124–125:
St. Louis Zoo Archway Model
(*Animals Always*), 2004
Cardboard, wood, red pencil
1.5 x 11 feet (.46 x 3.35 m)
Paley Studio Archive, PM 2004.01

above and opposite:
Production work on *Animals Always*
at North Washington Street Studio,
Rochester, New York.
(Paley, lower left, upper right
and opposite)

pp. 128–129
Animals Always, 2006
Formed and fabricated Cor-Ten steel
40 x 130 x 12 feet
(12.19 x 39.62 x 3.66 m)
St. Louis Zoological Park,
St. Louis, Missouri
Paley Studio Archive, PM 2004.01

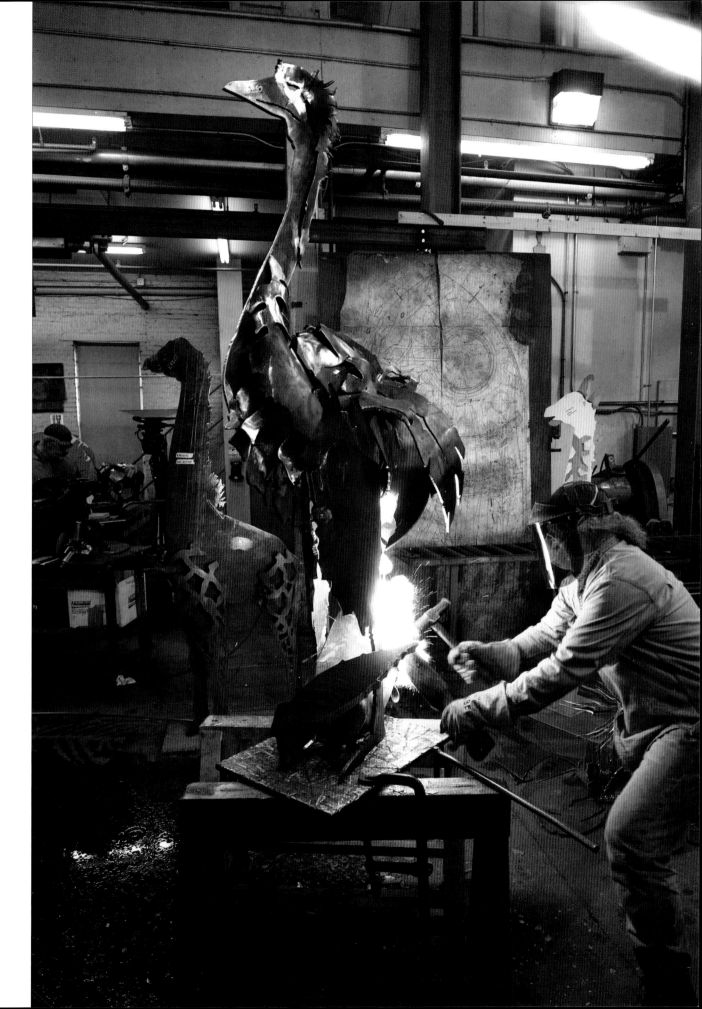

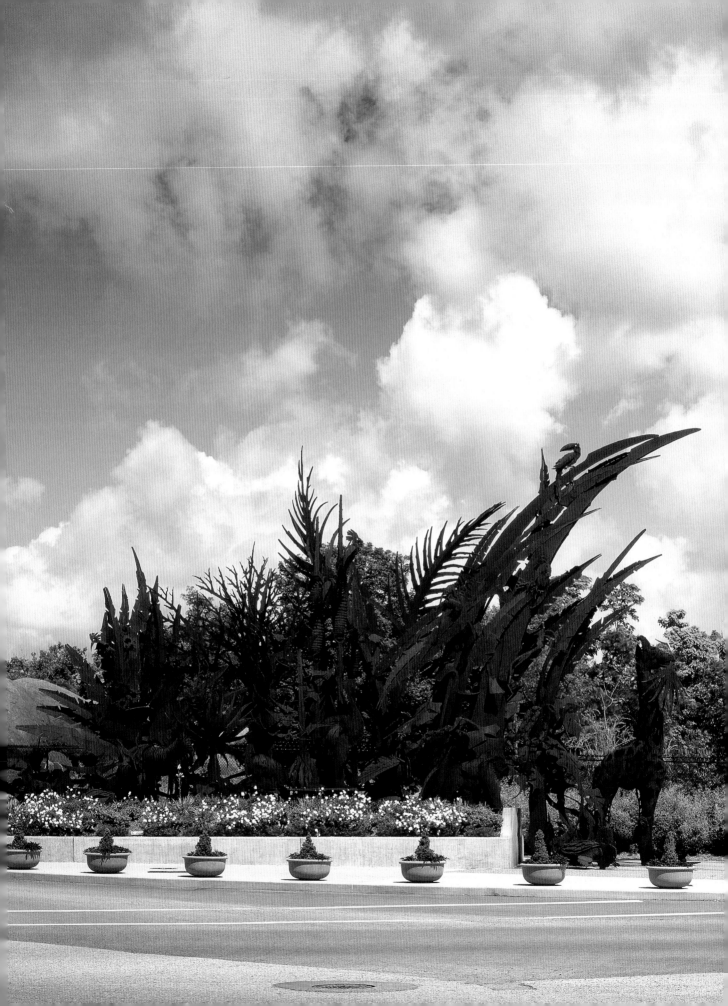

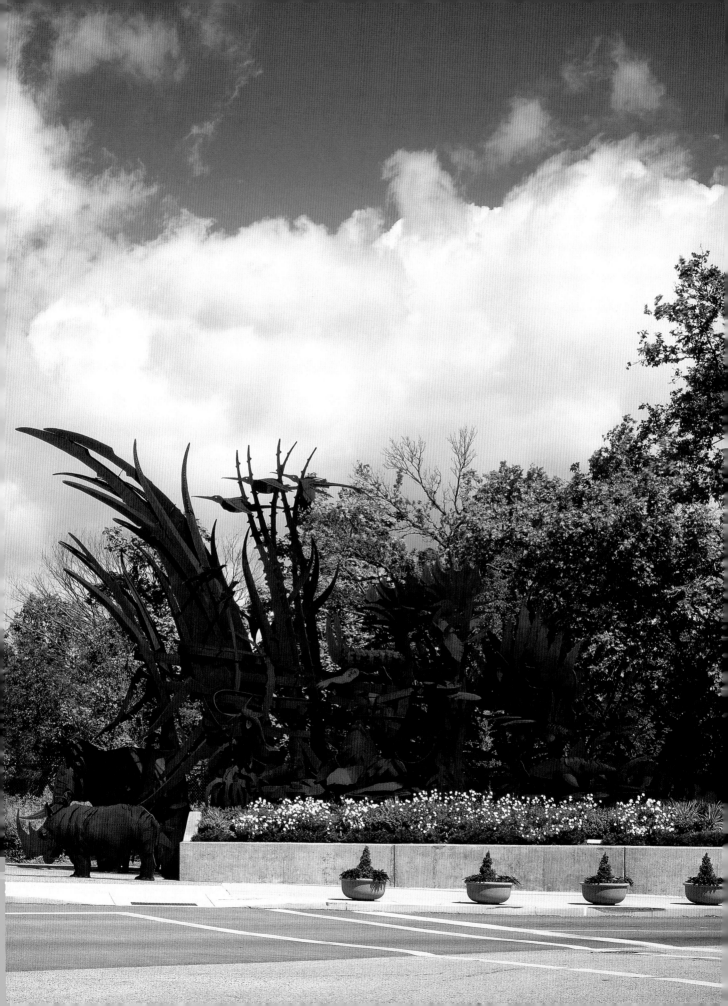

NATIONAL CATHEDRAL GATE 2007

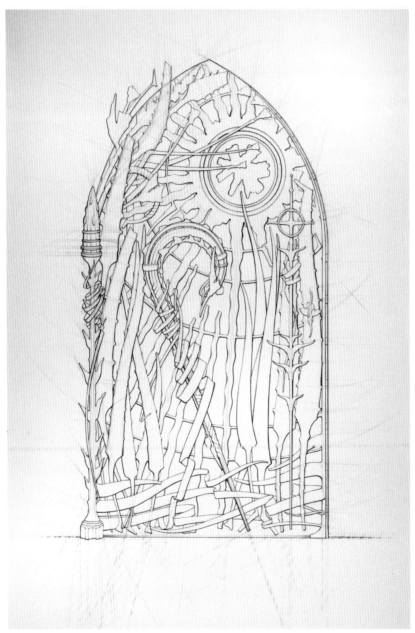

left: Study for Good Shepherd
Gate at the National Cathedral, 2005
Red pencil on paper
41 x 26.5 inches (104.14 x 67.31 cm)
Paley Studio Archive, GA 2005.02.02

right: Presentation Proposal
for the Good Shepherd Gate at the
National Cathedral (Final), 2005
Graphite and colored pencil on paper
13 x 9.5 inches (33.02 x 24.13 cm)
Paley Studio Archive, GA 2005.02.01

opposite: Design Study for the
Good Shepherd Gate at the National
Cathedral, 2007
Forged A-36 mild steel, brass,
24K gold plate
9 x 5 x 1 feet (2.74 x 1.52 x .30 m)
National Cathedral, Washington, D.C.
Paley Studio Archive, AG 2007.01b

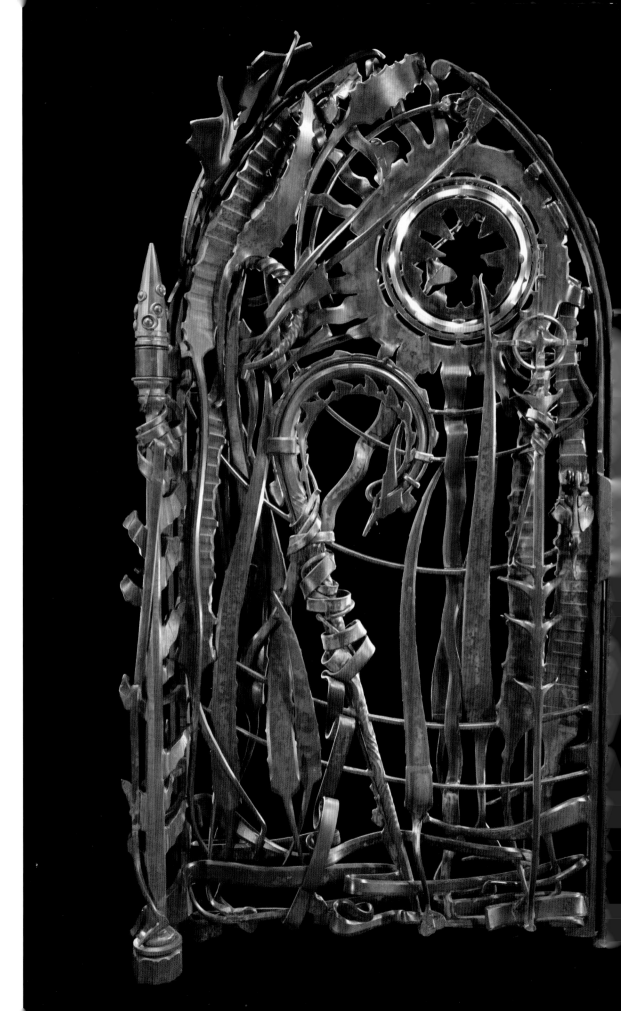

MARCH 28, 1944

Born in Philadelphia, Pennsylvania

EDUCATION

1997

Honorary Doctorate of Fine Arts, State University of New York at Brockport, Brockport, New York

1996

Honorary Doctorate of Fine Arts, St. Lawrence University, Canton, New York

1989

Honorary Doctorate of Fine Arts, University of Rochester, Rochester, New York

1966–69

Master of Fine Arts, Tyler School of Art, Temple University, Philadelphia, Pennsylvania

1962–66

Bachelor of Fine Arts, Tyler School of Art, Temple University, Philadelphia, Pennsylvania

TEACHING EXPERIENCE

1984 to present

Artist-in-Residence, *Charlotte Fredericks Mowris Endowed Chair*, College of Imaging Arts and Sciences, Rochester Institute of Technology, Rochester, New York

1972–84

Professor, State University of New York College at Brockport, Brockport, New York

1969–72

Assistant Professor, College of Fine and Applied Art, Rochester Institute of Technology, Rochester, New York

1968–69

Instructor, Tyler School of Art, Temple University, Philadelphia, Pennsylvania

PERMANENT COLLECTIONS

Arizona State University, Tempe, Arizona
Art Gallery of Western Australia, Perth, Australia
The Birmingham Museum of Art, Alabama
The British Museum, London, England
The Brooks Museum of Art, Memphis, Tennessee
Iris and B. Gerald Cantor Center for Visual Arts, Stanford University, California
Columbia Public Library, Columbia, Missouri
The Columbus Museum of Art, Columbus, Ohio
Cooper-Hewitt, Smithsonian Institution, Washington, D.C.
Delaware Art Museum, Wilmington, Delaware
Detroit Institute of Arts, Detroit, Michigan
Earlham College, Richmond, Indiana
The Fitzwilliam Museum, Cambridge University, England
Gannett Publishing Corporation, Washington, D.C.
High Museum of Art, Atlanta, Georgia
Hunter Museum of Art, Chattanooga, Tennessee
International Sculpture Center's Collection II

Iowa State University, Art on Campus Collection, Ames, Iowa
Memorial Art Gallery, University of Rochester, Rochester, New York
Metropolitan Museum of Art, New York, New York
Minneapolis Institute of Arts, Minneapolis, Minnesota
Minnesota Museum of American Art, St. Paul, Minnesota
Mint Museum of Art and Design, Charlotte, North Carolina
Museum of Art, Brigham Young University, Provo, Utah
Museum of Fine Arts, Boston, Massachusetts
Museum of Fine Arts, Springfield, Massachusetts
The Museum of Fine Arts Houston, Houston, Texas
The Newark Museum, Newark, New Jersey
Philadelphia Archdiocese, Philadelphia, Pennsylvania
Philadelphia Museum of Art, Philadelphia, Pennsylvania
Polk Museum of Art, Lakeland, Florida
Racine Art Museum, Racine, Wisconsin
Renwick Gallery, Smithsonian Institution, Washington, D.C.
State Capitol, Albany, New York
Strong Museum, Rochester, New York
Syracuse University, Syracuse, New York
Temple University, Philadelphia, Pennsylvania
Toledo Museum of Art, Toledo, Ohio
University of Illinois, Normal, Illinois
Victoria and Albert Museum, London, England
Virginia Museum of Fine Arts, Richmond, Virginia
The White House, Washington, D.C.
Worcester Art Museum, Worcester, Massachusetts
Yale University Art Gallery, New Haven, Connecticut

MAJOR COMMISSIONS

2007

Ritten House Square Plaza, Philadelphia, Pennsylvania; interior wall sculpture, fabricated and painted steel, 20 x 10 x 2 feet, Architects: Cope Linder, Philadelphia, Pennsylvania

Village of Hope, Orange County, California; exterior plaza sculpture, fabricated and polychromed steel, 25 x 12 x 12 feet; plaza sculpture, formed stainless steel, 8 x 8 x 6 feet; entrance portal, forged and painted steel, 15 x 25 x 1.5 feet

National Harbor, Alexandria, Virginia; exterior pylon sculptures, formed and fabricated Cor-Ten steel, 80 x 20 x 12 feet; Architects: Sasaki Associates, Boston, Massachusetts

Iowa State University, Ames, Iowa; Art on Campus Collection; *Transformation*, (entrance portal sculpture for Morrill Hall) formed and fabricated stainless steel, 15 x 15 x 2 feet and 9.6 x 10 x 2 feet.

National Cathedral, Washington, D.C.; *Good Shepherd Chapel Entrance Gates*, forged and patinated steel, 16 x 9 x 1 feet and 11 x 2 x 1 feet

2006

Klein Steel Corporation, Rochester, New York; *Threshold*, (exterior sculpture), fabricated and painted steel, 67 x 40 x 36 feet

St. Louis Zoological Park, St. Louis, Missouri; *Animals Always*, (exterior plaza sculpture), formed and fabricated Cor-Ten steel, 40 x 130 x 12 feet

2005

Memphis Museum of Art, Memphis, Tennessee; *Entrance Portals*, (exterior gates), forged and painted steel, 15.25 x 1.5 x 14.5 feet

2004

North Bridge Commons, Orlando, Florida; *Rhapsody*, (exterior sculpture), formed, fabricated and polychromed steel, 26.6 x 7 x 7 feet

Monahan Pacific Development Corporation, San Francisco, California; *Volute*, (exterior sculpture), formed and fabricated stainless steel, 11.3 x 3.3 x 3 feet

M D Andersen Ambulatory Clinical Building, Houston, Texas; *Tree of Life*, (interior sculpture), formed, fabricated and polychromed steel, 22.5 x 19 feet

D C Commission on the Arts and Humanities, Washington, D.C.; *Epoch*, (exterior sculpture), formed, fabricated and polychromed steel, 24 x 12 x 10.5 feet

Lake Mirror Park, Lakeland, Florida; *Tribute to Volunteerism*, (exterior sculpture). formed, fabricated and polychromed steel, 41 x 9.1 x 10.5 feet

Cleveland Botanical Garden, Cleveland, Ohio; *Kohl Gate*, (ceremonial archway), formed and fabricated Cor-Ten steel, 14.8 x 55.25 x 3.2 feet; Architect: Graham Gund, East Cambridge, Massachusetts

2003

Rochester Institute of Technology, Rochester, New York; *Sentinel*, (exterior sculpture), formed and fabricated Cor-Ten, stainless steel and bronze, 73 x 30 (diameter) feet

Syracuse University, Syracuse, New York; *Banner*, (exterior sculpture), fabricated Cor-Ten steel, 9.4 x 2.25 x 1.8 feet

2002

Hotel Pattee, Perry, Iowa; *Reconfiguration*, (one pair of gateway sculptures for city park), fabricated found objects with painted finish, 25.6 x 28 x 7.3 feet and 19 x 24.5 x 6.5 feet

Wellington Place, Toronto, Canada; *Constellation*, (relief sculpture for building façade), formed and fabricated stainless steel, 15.8 x 2.6 x 18 feet; Architects: Page & Steel Architects, Toronto, Canada

Columbia Public Library, Columbia, Missouri; *Cypher*, (pair of entrance sculptures), formed, fabricated and polychromed steel, 38.75 x 18 x 11 feet and 30.3 x 11.5 x 21 feet; Architect: Hardy, Holzman and Pfeiffer, New York, New York

2001

Florida Gulf Coast University, Fort Myers, Florida; *Cross Currents,* (exterior sculpture), formed, fabricated and polychromed steel, 21.8 x 12 x 8 feet

La Cienega Center, Beverly Hills, California; *Oblique,* (exterior sculpture), formed and fabricated Cor-Ten, stainless steel and bronze, 23 x 12.3 x 7.5 feet

2000

University of the South, Sewanee, Tennessee; *Relief Sculpture,* formed and fabricated steel and bronze, 8.25 x 14 x .5 feet; Architect: Hardy, Holzman and Pfeiffer, New York, New York

Naples Philharmonic Center for the Arts, Naples Florida; *Portal Gates,* formed and fabricated steel, stainless steel, and bronze. 20 x 10.6 x 1.3; Architect: HKS Architects, Orlando, Florida

1999

Florida State University, Tallahassee, Florida; *Stadium Entrance,* formed and fabricated steel, stainless steel and bronze, 12.5 x 36 x .5 feet

Toledo Museum of Art, Toledo, Ohio; Design of public space, wall sculpture and interior furnishings, formed and fabricated stainless steel, 12 x 12.5 feet

1998

Adobe Systems, Inc., San Jose, California; *Horizon,* (exterior sculpture, water fountain and lighting features for plaza complex), formed and fabricated weathering steel, stainless steel, bronze, natural patina, 28 x 37 x 7 feet and 9 x 7 x 7.5 feet

The Municipality of Anchorage, Anchorage, Alaska; *Solstice,* (exterior sculpture), formed and fabricated steel and stainless steel with natural patina and polychrome, 25.5 x 8.5 x 7.5 feet

The University of Toledo, Toledo, Ohio; *Symbion,* (exterior plaza sculpture), formed, fabricated and polychromed weathering and stainless steel with natural patina, 27.75 x 11.6 x 8 feet

1997

San Francisco Art Commission, California, for the Civic Center Courthouse; *Exterior Entrance Doors, Rotunda Lobby Gates, Elevator Doors,* formed and fabricated stainless steel, 10.3 x 6.75 feet

The Ohio State University, Columbus, Ohio; *Gnomon,* (exterior sculpture), formed and fabricated weathering steel with natural patina, 19.5 x 8.5 x 8 feet

Canandaigua Wine Company, Canandaigua, New York; *Helix,* (exterior sculpture), formed and fabricated weathering steel with natural patina, 16 x 15 x 38.5 feet

American Bankers Insurance Group, Miami, Florida; *Exterior Sculpture,* formed, fabricated and polychromed steel, 17.5 x 8.3 x 5.4 feet

Victoria and Albert Museum, London, England; Benefactors' *Wall Sculptures,* (honorary awards), formed and fabricated steel, 15 x 16.5 x 1.5 inches

Miami University, Oxford, Ohio for Alumni Hall; *Library Entrance,* formed and fabricated bronze, 6 x 1 x .5 feet

1996

Bausch and Lomb, Rochester, New York for the new corporate headquarters; *Genesee Passage,* (exterior sculpture), formed and fabricated weathering steel, 60 x 16 x 12 feet; Architects: Fox and Fowl, New York City, New York

Sony Pictures Entertainment, Culver Studios Office Building, Culver City, California; *Primordial Reflections,* (exterior relief panels), formed, fabricated and painted steel, 6.6 x 21.4 x .8 feet

Congregation Adath Jeshurun, Elkins Park, Pennsylvania; *Revelation,* (temple tabernacle doors), formed and fabricated steel, 24.4 x 12.75 x 3.25 feet

1995

General Services Administration, Washington, D.C. for the New Federal Building in Asheville, North Carolina; *Passage,* (exterior sculpture), formed and fabricated weathering steel, 37 x 23 x 16 feet

1994

General Services Administration, Washington, D.C. for the Federal Courthouse, Camden, New Jersey; *Metamorphosis,* (interior rotunda sculpture), formed, fabricated and polychromed steel, 9 x 11 x 1.5 feet

Rosecliff Incorporated, Peter Joseph Offices, New York, New York; Interior entrance portal, corporate boardroom entrance, architectural details and furnishings, formed and fabricated steel with natural patina, 8.8 x 6.75 x .5 feet

Temple Israel, Dayton, Ohio; *Tabernacle Screen,* formed, fabricated and polychromed steel, 7.6 x 8.6 x .5 feet; Architects: Hardy, Holzman & Pfeiffer, New York, New York

Victoria and Albert Museum, London, England; *Museum Bench,* forged and fabricated steel and mahogany, 2.25 x 11.25 x 2.5 feet

1992

Montgomery County, Silver Springs, Maryland; *Criss-Cross,* (exterior sculpture), formed, fabricated and polychromed steel, 20 x 30 x 10 feet

1991

Arizona State University, Tempe, Arizona; *Ceremonial Gates,* (exterior gate), formed, fabricated and polychromed steel, 12 x 8 x 1.5 feet; Architect: Coover, Saemisch, & Anderson, Phoenix, Arizona

1990

The Landmarks Group, Promenade Two Building, Atlanta, Georgia; *Olympia,* (exterior sculpture), formed, fabricated and polychromed steel, 29 x 14 x 8 feet; Architect: Thompson, Ventulett, Stainback & Associates, Inc., Atlanta, Georgia

Arts Council of Roanoke Valley, Roanoke Airport Authority, Roanoke Regional Airport, Roanoke, Virginia; *Aurora,* (exterior sculpture), forged, fabricated and polychromed steel, 18 x 12 x 6 feet

Birmingham Museum of Art, Birmingham, Alabama; *Confluence,* (exterior sculpture), formed and fabricated Cor-Ten steel, 18 x 10 x 4 feet

1988

Cornell University Medical College, Lasdon Biomedical Research Building, New York, New York; *Architectural Screen,* (interior sculpture), forged, fabricated and polychromed steel, 6 x 8 x 1 feet; Architects: Payette Associates, Boston, Massachusetts.

Memorial Art Gallery of the University of Rochester, Rochester, New York; *Convergence,* (interior sculpture), forged, fabricated and painted steel, 8 x 6 x 3 feet

State of Connecticut, Bureau of Public Works, for the Hartford Superior Court Building, Hartford, Connecticut; *Hexad,* (interior sculpture), forged and fabricated painted steel and bronze, 21 x 12 (diameter) feet

1987

Houston Lyric Theater Foundation, Inc., Houston, Texas, for the Wortham Center for the Performing Arts; *Stairway Sculptures,* (eight interior sculptures), formed, fabricated and polychromed steel, varying in height from 15 to 30 feet; Architects: Morris Architects, Houston, Texas

Massachusetts Bay Transit Authority, Milk Street Station, Boston, Massachusetts; *Entrance Gateway,* forged, fabricated and painted steel, 10 x 10 feet

Redevelopment Authority of the City of Philadelphia for Museum Towers, Philadelphia, Pennsylvania; *Synergy,* (archway exterior sculpture), formed, fabricated and polychromed steel, 25 x 60 x 6 feet; Architects: Salkin Group, Philadelphia, Pennsylvania

1986

Gannett Publishing Corporation, Washington, D.C.; *Bronze Wall Relief,* forged and fabricated bronze, 6 x 15 x 1 feet; Architects: Burwell-Bantell Architects, Rochester, New York

New York State Council on the Arts, New York, New York; *New York State Governor's Art Awards,* forged and fabricated steel, 18 x 4 (dia.) inches

Virginia Museum of Fine Arts, Richmond, Virginia; *Pedestrian Entrance Gate,* forged, fabricated and painted steel, 8 x 8 feet; *Vehicular Entrance Gate,* formed, fabricated and painted steel, 11.5 x 32 feet; Architects: Hardy, Holzman & Pfeiffer, New York, New York

The Willard Building, Washington, D.C.; *Sculpture,* (interior), forged and fabricated steel and bronze, 8 feet 2 inches x 5 feet 11 inches x 1 foot 6 inches; Architect: Valstimil Koubeck, Washington, D.C.

1984

Harro Theater East, Rochester, New York; *Conclave,* (exterior sculpture), formed, fabricated and painted steel, 30 x 22 x 10 feet

1983

The Hyatt Corporation, for the Hyatt Grand Cypress Hotel, Orlando, Florida; *Entrance Sculpture,* forged and fabricated steel and bronze, 19.5 x 8.5 x 7.8 feet

Quadrangle Development, for the J. W. Marriott Hotel, Washington, D.C.; *Architectural Screen,* forged and fabricated steel and bronze, 5 x 25 feet

1982
Strong Museum, Rochester, New York; *Sculpture,* (exterior), hollow formed and fabricated Cor-Ten steel, 15.5 x 31.5 x 6 feet; Architect: Carl Kalber

1981
Pennsylvania Avenue Redevelopment Corporation, Washington, D.C.; *Tree Grates,* cast iron, 800 grates: 88 inches diameter each; 30 benches, 68 inches diameter each

1980
New York State Senate, Albany, New York for State Senate Chambers, Capitol; *Portal Gates,* (two pair of interior gates), forged and fabricated steel, brass, and bronze, 13.5 x 9 x .5 feet each; Architects: Mendel, Mesick and Cohen.

1978
Redevelopment Authority of the City of Philadelphia, Philadelphia, Pennsylvania; *Sculpture Screens,* forged and fabricated steel, 6 x 4 feet; *Two Gates,* forged and fabricated steel, 3 x 8 feet; Architects: Louis Sauer Associates, Philadelphia, Pennsylvania

1975
Hunter Museum of American Art, Chattanooga, Tennessee; *Sculpture Court Enclosure,* (exterior sculptures), forged, fabricated and painted steel, varying in height from 6 to 12 x 87.5 feet

1974
Renwick Gallery, National Museum of American Art, Smithsonian Institution, Washington, D.C.; *Portal Gates,* (interior gates), forged and fabricated steel, brass, and bronze, 7.5 x 6 x .5 feet

ONE-PERSON EXHIBITIONS

2007
Albert Paley | Portals & Gates, University Museums, Iowa State University: Christian Petersen Art Museum and the Brunnier Art Museum, Ames, Iowa; Hometown Perry, Iowa.

2004
The Artist Responds: Albert Paley and Art Nouveau, Racine Art Museum, Racine, Wisconsin

2003
Points of Entry: The Drawings of Albert Paley, Kimberly Venardos and Company, Inc. New York, New York

2002
Albert Paley: Process, Mint Museum of Art and Design, Charlotte, North Carolina

2001
Albert Paley/Sculpture, Drawings, Graphics, & Decorative Arts, Florida State University Museum of Fine Art, Tallahassee, Florida. (traveling exhibition, 2001-2003)
Gulf Coast Museum of Art, Largo, Florida
Polk Museum of Art, Lakeland, Florida
Terrace Gallery, City of Orlando, Orlando, Florida

2000
Albert Paley: Sculpture, Galerie Simonne Stern, New Orleans, Louisiana
Albert Paley: Art in Architecture, Gremillion Fine Art, Houston, Texas

1999
Albert Paley: Organic Complexity, Gremillion and Co. Fine Art, Houston, Texas

1998
Albert Paley: A Dialogue of Architecture, Decorative Arts and Design, Chicago Design Show, Chicago, Illinois

1997
Albert Paley: Selected Sculpture, Riva Yares Gallery, Scottsdale, Arizona

1996
Age of Steel: Recent Sculpture by Albert Paley, Museum of Art, Brigham Young University, Provo, Utah
Albert Paley, Riva Yares Gallery, Scottsdale, Arizona

1995
Albert Paley: Sculpture & Drawings, Chang Gallery, Kansas State University, Manhattan, Kansas

1994
Albert Paley: Drawings and Sculpture, Temple Gallery, Philadelphia, Pennsylvania
Albert Paley: Organic Logic, Peter Joseph Gallery, New York, New York
Inspiration & Context: The Drawings of Albert Paley, Memorial Art Gallery of the University of Rochester, Rochester, New York, (touring exhibition)
 City of Orlando, Florida
 The Hunter Museum of American Art, Chattanooga, Tennessee
 The Delaware Art Museum, Wilmington, Delaware
 The Burchfield-Penney Art Center, Buffalo, New York
 St. Bonaventure University, Olean, New York

1993
Sculpture by Albert Paley, San Antonio Art Institute, San Antonio, Texas

1992
Albert Paley: Recent Sculpture, Samuel P. Harn Museum of Art, University of Florida, Gainesville, Florida
Albert Paley: Studies for the "Portal Gates," Renwick Gallery, Smithsonian Institution, Washington, D.C.

1991
Albert Paley: Sculpture, University of the Arts, Philadelphia, Pennsylvania and the Naples/Marco Philharmonic Center for the Arts, Naples, Florida
Albert Paley: 1980–1990, Barbara Fendrick Gallery, New York, New York
Albert Paley: Architectural Metalwork, Hellmuth, Obata & Kassabaum, Washington, D.C.

1990
Albert Paley: Recent Works, Gerald Peters Gallery, Santa Fe, New Mexico
Albert Paley, Roanoke Museum of Fine Arts, Roanoke, Virginia

1989
Albert Paley, National Museum of Wales, Cardiff, Wales, The United Kingdom

1985–86
Albert Paley: The Art of Metal (retrospective touring exhibition, 1972–1986)
Birmingham Museum of Art, Birmingham, Alabama
Columbus Museum of Art, Columbus, Ohio
Memorial Art Gallery, University of Rochester, Rochester, New York
Museum of Art, Springfield, Massachusetts
Virginia Museum of Fine Arts, Richmond, Virginia

1983–84
The Iron Aesthetic, Fendrick Gallery, Washington, D.C.

1983
Albert Paley, The University of Iowa Museum of Art, Iowa City, Iowa

1980
The Metalwork of Albert Paley (retrospective touring exhibition, 1962–1975)
Columbus Gallery of Fine Arts, Columbus, Ohio
Hunter Museum of American Art, Chattanooga, Tennessee
John Michael Kohler Arts Center, Sheboygan, Wisconsin

1977
Recent Works in Metal by Albert Paley, Renwick Gallery, Smithsonian Institution, Washington, D.C.

1976
Cornell University, Ithaca, New York

1973
Memorial Art Gallery, University of Rochester, Rochester, New York
Tyler School of Art, Temple University, Philadelphia, Pennsylvania

1972
Earlham College, Richmond, Indiana

1971
New Directions Gallery, University of Illinois, Normal, Illinois

1970
Nova Scotia College of Art and Design, Halifax, Nova Scotia, Canada

1969
Philadelphia Art Alliance, Philadelphia, Pennsylvania

INTERNATIONAL EXHIBITIONS

2006
American Sculptors, St. Urban, Switzerland

2005
Open Spaces, Vancouver Sculpture Biennale, 2005–2006, Vancouver, British Columbia, Canada
Transformations, National Gallery of Australia, Canberra, Australia

2004
Art Toronto, 2004, Toronto, Ontario, Canada

2003
Second International Sculpture Exhibition, Chetumal, Mexico

2002
First International Sculpture Exhibition, Colima,
Mexico

1999
Congju International Biennale '99, Congju City, Korea

1997
Albert Paley: Selected Works, Fine Art Society,
London, England
Art Expo Chicago, selected work from the Richard
Gray Gallery, Chicago, Illinois

1995
International Exhibition, Won-Kwang University,
Iri City, Republic of South Korea

1992
*"Design Visions" Exhibition, The Second Australian
International Triennial,* Museum of Western
Australia, Perth, Australia
Tokyo Art Expo, exhibition of sculpture and project
documentation, Tokyo, Japan

1991
Japan/USA Invitation Exhibition, Kanazawa, Japan

1989
Albert Paley, Ironbridge Gorge Museum,
Telford, England
Traveling Exhibition, sponsored by the United States
Information Agency, Washington, D.C.,
(European touring exhibition)
Musée des Arts Décoratifs, Paris, France
Museum of Applied Art and Design,
Helsinki, Finland
Museum für Kunsthandwerk, Frankfurt, Germany
Zacheta Gallery, Warsaw, Poland
Musée des Arts Décoratifs, Lausanne,
Switzerland
Museum of Decorative & Applied Folk Art,
Moscow, Russia
Ankara Resim ve Heykel Müzesi (State Painting
& Sculpture Museum), Ankara, Turkey
The Oslo Museum of Applied Art, Oslo, Norway
St. Peter's Abbey, Ghent, Belgium
Amerika Haus, Berlin, Germany
The Zappeion, Athens, Greece
Slovak National Gallery, Bratislava, Czechoslovakia
The Grassi Museum, Leipzig, Germany
Sala Sant Jaume de la Fundacio "La Caixa",
Barcelona, Spain
The Gulbenkian, Lisbon, Portugal

1986–87
Design in America, a cultural exchange exhibition
in Yugoslavia, sponsored by the United States
Information Agency, Washington, D.C.
Cankarjev Dom, Ljubljana
Muzej za Umjetnost i Obrt, Zagreb
Umetnicki Paviljon, Cvijeta Zuzoric, Belgrade
Collegium Artisticum, Sarajevo

1986
First World Congress of Iron, Aachen, West Germany

1983
Towards a New Iron Age, Victoria and Albert
Museum, London, England (touring exhibition)
Flint Institute of Art, Michigan
The Mint Museum, Charlotte, North Carolina

National Ornamental Metal Museum,
Memphis, Tennessee
University Museum, Southern Illinois University,
Carbondale, Illinois

1978
Art and Religion, Vatican Museum and Galleries,
Rome, Italy

1976
Invitational Design Exhibition, Zlatarna, Celje,
Yugoslavia; Merit Award.

BOOKS

Bach, Penny Balkin. *Public Art in Philadelphia.*
Philadelphia, Pennsylvania: Temple University
Press, 1992.
Bishop, Robert and Patricia Coblents. *American
Decorative Arts: 360 Years of Creative Design.*
New York, New York: Harry N. Abrams, Inc., 1982.
Byars, Mel. *The Design Encyclopedia.* New York,
New York: John Wiley & Sons, Inc., 1994.
Campbell, Marian. *An Introduction to Ironwork.*
London, England: Her Majesty's Stationery
Office, 1985.
Christ, Ronald and Dennis Dollens. *New York:
Nomadic Design.* Barcelona, Spain: Gustavo Gilli,
S.A., Distributed in US by Rizzoli International
Publications, NYC, 1983, ill., p. 44.
*Collecting American Decorative Arts and Sculptures -
1971–1991.* Boston, Massachusetts: Museum of
Fine Arts, 1991.
Diamondstein, Barbaralee. *Handmade in America.*
New York, New York: Harry N. Abrams, Inc., 1983.
Dictionary of International Biography. London,
England, 1972.
Greenhalgh, Paul. *The Persistence of Craft.*
A & C Black, London, England, 2002.
Holzman, Malcolm. *Stone Work: designing with stone.*
Victoria, Australia, Images Publishing Group, 2002.
Jensen, Robert and Patricia Conway.
Ornamentalism. New York, New York:
Clarkson N. Potter, Inc., 1982.
Kuspit, Donald. *Albert Paley: Sculpture.*
Milan, Italy: Skira, 2006.
Lucie-Smith, Edward. *The Art of Albert Paley.*
(monograph), New York, New York: Harry N.
Abrams, Inc., 1996.
Lucie-Smith, Edward. *Art Today.* London, England:
Phaidon Press Limited, 1995.
McMaster, Julie A. *The Enduring Legacy: A Pictorial
History of the Toledo Museum of Art.* Toledo,
Ohio: Toledo Museum of Art, 2001.
Meilach, Dona Z. *Decorative and Sculptural
Ironwork.* New York, New York: Crown, 1977.
Miller, R. Craig. *Modern Design In the
Metropolitan Museum of Art: 1890–1990.*
New York, New York: Harry N. Abrams, Inc., 1990
Minamizawa, Hiroshi. *The World of Decorative &
Architectural Wrought Iron.* Kyoto, Japan: Yoshiyo
Kobo Co., Ltd., 1990.
National Museum of American Art. *National
Museum of American Art.* Washington, D.C.:
Smithsonian Institution, 1995.
Park, Edward S. *Treasures of the Smithsonian.*
Washington, D.C.: Smithsonian Institution, 1983.

Rowe, M. Jessica and others, *Albert Paley | Portals
& Gates,* Ames, Iowa: University Museums, Iowa
State University, 2007.
Toledo Museum of Art. *Toledo Treasures.* New York,
New York: Hudson Hills Press, 1995.
Trilling, James. *Ornament: A Modern Perspective,*
Seattle, Washington, University of Washington
Press, 2003.
Verlag, Julius Hoffmann. *Kunst aus dem Feuer
(Art from the Fire).* Stüttgart, Germany:
Hoffmann, 1987.
Yarrington, James and other, *Sentinel,* Rochester,
New York, Rochester Institute of Technology
Cary Press, 2005.

EXHIBITION CATALOGUES

Albert Paley: Age of Steel. Provo, Utah: Museum
of Art, Brigham Young University, 1996.
Albert Paley: Recent Works. Gainesville, Florida:
Samuel P. Harn Museum of Art, University of
Florida, 1992.
Albert Paley: Sculpture. New York, New York:
Barbara Fendrick Gallery, 1989.
*Albert Paley: Sculpture, Drawings, Graphics, and
Decorative Arts.* Tallahassee, Florida: Florida
State University Museum of Fine Arts, School of
Visual Arts and Dance, 2001.
Albert Paley: Sculptures. Philadelphia, Pennsylvania:
Rosenwald-Wolf Gallery - Philadelphia College of
Art and Design at The University of the Arts, 1992.
Albert Paley: The Art of Metal. Springfield,
Massachusetts: Museum of Fine Arts, 1985.
Albert Paley: The Iron Aesthetic. Washington, DC:
Fendrick Gallery, 1983.
Albert Paley: The Paradox of Iron. Washington, DC:
Fendrick Gallery, 1982.
Architectural Art: A Discourse. New York, New York:
Museum of Art and Design, 1988.
*Art to Art: Albert Paley, Jim Dine, Therman Statom
Respond to Toledo's Treasures.* Toledo, Ohio: The
Toledo Museum of Art, 1996.
*Art and Religion, Second International Exhibition:
1978.* New York: The Committee of Religion and
Art of America, Inc. for Smithsonian Institution,
Washington, DC, and The Vatican Museum and
Galleries, Rome, Italy, 1978.
Decorative Metalwork in Architecture. Minneapolis,
Minnesota: University of Minnesota, 1986.
*8th General Assembly and International Conference,
Kyoto, Japan.* New York: World Crafts Council, 1978.
Inspiration & Context: The Drawings of Albert Paley.
Rochester, New York: Memorial Art Gallery of the
University of Rochester, 1994.

FILM AND VIDEO

2006
Machi, Tony, *Albert Paley: Sentinel.* Produced and
directed by Tony Machi, Machi and Machi
Productions. (Approx. 60 min. High Definition
video) PBS National Broadcast.

1999

Machi, Tony, *Albert Paley: Man of Steel*. Produced and directed by Tony Machi, Machi and Machi Productions. (Approx. 57 min. video color/sound) PBS National Broadcast, January 12, 2001.

1994

Albert Paley - Metal Artist. NHK TV (Japanese Public Television). In Japanese (Approx. 20 min., HDTV color/sound).

1991

Albert Paley: Sculptures. Rosenwald-Wolf Gallery, Philadelphia College of Art & Design, The University of the Arts. A video documentation of works in progress for this exhibition. (Approx. 20 min., Video color/sound).

1987

Albert Paley's Albany Gates. Produced and directed by Bill Rowley (58 min., 16mm color/sound).

Made in America: Albert Paley and Wendell Castle. Produced and directed by Tony Machi. Local Broadcast WXXI, Rochester, November 1987. National Broadcast, PBS, October 1988. (58 min., video color/sound).

1986

Albert Paley: Architectural Metal Sculptor. Produced and directed by John P. Dworak, Virginia Museum of Fine Arts, Richmond, Virginia. Aired on Public Broadcasting System (28 min. 30 sec.).

Albert Paley: Sculpted Steel. Produced by Anne-Marie Fendrick, commissioned by the Springfield Museum of Fine Arts, Springfield, Massachusetts (11 min.).

Decorative Metalwork in Architecture. Videotape lectures, "Paley Studios Ltd./Survey of Historical Metalworking," and panel discussion. University of Minnesota, Minneapolis, Minnesota.

'80's Style. Videotape panel discussion: Wendell Castle, Agnes Dennis, Edward Lucie-Smith, Albert Paley, Ettore Sottsass, Massimo Vignelli; Rochester Institute of Technology, Rochester, New York (60 min., approx.).

1983

Hand and Eye ("Against Oblivion"). Canadian Broadcasting Company.

1982

Handmade in America: Interview with Albert Paley. Produced by Barbaralee Diamondstein for ABC Video Enterprises, American Broadcasting Corporation, New York (23 min., color, sound).

1976

Behind the Fence: Albert Paley, Metalworker. Produced by David Darby. Viewed - National Public Broadcasting (30 min., color, sound). Award, 2nd International Film Festival, New York State Council of the Arts, New York, New York.

AWARDS AND GRANTS

1997

Masters of the Medium Award, James Renwick Alliance, Renwick Gallery, Smithsonian Institution, Washington, D.C.

1995

Citations and Fellowship Award, National Association of Schools of Art and Design (NASAD)

Institute Honors, *Lifetime Achievement Award for Dialogue of Art and Architecture*, The American Institute of Architects (AIA), National Committee on Design

1991

Artist's Fellowship, New York Foundation for the Arts, New York, New York

1988

Art in Public Space Award, DFA Ltd.

1984

Visual Artists' Fellowship Grant, National Endowment for the Arts, Washington, D.C.

1982

Award of Excellence, American Institute of Architects: Art in Architecture (*Portal Gates*, New York State Senate Chambers, Albany, New York)

1981

Certificate of Honor Award, Tyler School of Art, Temple University, Philadelphia, Pennsylvania

1979

Master Apprenticeship Grant, National Endowment for the Arts, Washington, D.C.

Japan/United States Exchange Program, National Endowment for the Arts

1978

Fulbright Fellowship in New Zealand and Washington, D.C.

1976

Master Apprenticeship Grant, National Endowment for the Arts, Washington, D.C.

International Design Exhibition, Zlatarna Celije, Celije, Yugoslavia, Design Award

INVITATIONAL EXHIBITIONS

2002

The Bayfront Exhibition 2002/2003, Sarasota Season of Sculpture, Sarasota, Florida

2001

Palm Springs International Art Fair, Palm Springs, California

Art Miami, Miami Beach, Florida

Georgia and David K. Welles Sculpture Garden, Toledo Museum of Art, Toledo, Ohio

1999

Inaugural Exhibition for New Gallery, Imago Gallery, Palm Desert, California

1996

Art to Art: Albert Paley, Jim Dine, and Therman Statom Respond to Toledo's Treasures, The Toledo Museum of Art, Toledo, Ohio

The Seattle Art Fair, Seattle, Washington

1995

Eightieth Anniversary Exhibition, Philadelphia Art Alliance, Pennsylvania

Los Angeles Art Expo, Los Angeles, California

Prague: Secret Fire, Frick Gallery, University of Pittsburgh, Pennsylvania

1994

Allusion/Illusion, Florida State University Museum of Fine Arts, Tallahassee, Florida.

San Francisco Art Expo, San Francisco, California

1993

Modern Metalwork in the Metropolitan Museum of Art, Metropolitan Museum of Art, New York, New York

1991

Collecting American Decorative Arts and Sculpture: 1971–1991, Museum of Fine Arts, Boston, Massachusetts

1988

Architectural Art: Affirming the Design Relationship, American Museum of Art and Design, New York, New York (touring exhibition)

Trammel-Crow Center, Dallas, Texas

Murry Feldman Gallery, Los Angeles, California

Pacific Design Center, Los Angeles, California

Huntsville Museum of Art, Huntsville, Alabama

Oklahoma City Art Museum, Oklahoma City, Oklahoma

1983

Ornamentalism: The New Decorativeness in Architecture and Design, The Hudson River Museum, Yonkers, New York; and Archer M. Huntington Art Gallery, University of Texas, Austin, Texas

Towards a New Iron Age, Victoria and Albert Museum, London, England (touring exhibition)

American Museum of Art and Design, New York, New York

Flint Institute of Art, Flint, Michigan

The Mint Museum, Charlotte, North Carolina

1980

Central New York Sculptors, Joe and Emily Lowe Art Gallery, Syracuse, New York

1978

Art and Religion, Smithsonian Institution, Washington, D.C.; and the Vatican Museum and Galleries, Rome, Italy

1977

Contemporary Works, Museum of Fine Arts, Boston, Massachusetts

Cranbrook Academy of Art, Bloomfield Hills, Michigan

1975

Hunter Museum of American Art, Chattanooga, Tennessee

1974

Iowa State University, Ames, Iowa

1973

Up the '70's, Rohm and Haas, Philadelphia, Pennsylvania

1972

Radial 80, Xerox Square Exhibition Center, Rochester, New York

1968

American Institute of Architects Exhibition, American Institute of Architects, Philadelphia, Pennsylvania

ALBERT PALEY | PORTALS & GATES

Christian Petersen Art Museum, University
Museums, Iowa State University (CPAM)
Brunnier Art Museum, University Museums, Iowa
State University (BAM)
Carnegie Library Museum, Hometown Perry, Iowa (HP)

The abbreviations "CPAM," "BAM," and "HP"
indicate the exhibition venue during the time period
from August 30, 2007 through January 15, 2008.

All objects are listed in chronological order.
The dimensions are described by inches and feet
in the order of height x width x depth (diameter),
followed by centimeters and meters. Unless
otherwise indicated, works of art are from the
collection of the artist.

Untitled Drawing, 1964
Ink on paper
paper: 13.75 x 22 inches (34.9 x 55.9 cm);
image: 12 x 19.5 inches (30.5 x 49.5 cm)
Paley Studio Archive, DWG 1964.01
CPAM

Study for the Portal Gates
(for the Renwick Gallery), ca. 1972
Ink on paper
23 x 17 inches (58.4 x 43.2 cm)
Private Collection
CPAM

Study for the Portal Gates
(for the Renwick Gallery), ca. 1972
Ink on paper
23 x 17 inches (58.4 x 43.2 cm)
Private Collection
CPAM

Study for the Portal Gates ·
(for the Renwick Gallery), ca. 1972
Ink on paper
23 x 17 inches (58.4 x 43.2 cm)
Private Collection
CPAM

Study for the Portal Gates
(for the Renwick Gallery), 1972
Ink on board, 27.5 x 37.25 inches
(69.85 x 94.62 cm)
Private Collection
Paley Studio Archive: GA 1972.01.18
CPAM

Portal Gates, 1974
Forged and fabricated mild steel, brass,
bronze, copper
7.5 feet x 6 feet x 4 inches (2.29 m x 1.83 m x 10.2 cm)
Signed middle vertical "1974 Albert Paley"
Collection of Smithsonian American Art Museum,
Washington, D.C., Commissioned for the Renwick
Gallery, 1975.117.1a-b
(Paley Studio Archive, AG 1974.01)
CPAM

Rectilinear Gate, 1976
Forged and fabricated mild steel; black patina
90 x 35 x 5.5 inches (229 x 89 x 14 cm)
Stamped "Paley 1976"
Paley Studio Archive, AG 1976.01
CPAM

Victoria and Albert Gate, 1982
Forged and fabricated mild steel with black patina
Signed, stamped "Albert Paley 1982"
82.5 x 106.5 x 13.5 inches (with base)
(209.6 x 270.5 x 34.3 cm)
Paley Studio Archive, AG 1982 01
CPAM

Gate (for Ackland Art Museum, University
of North Carolina at Chapel Hill), 1988
Graphite on paper
paper: 18 x 24 inches (45.7 x 61 cm);
image: 13 x 14 inches (33 x 35.6 cm)
Paley Studio Archive, GA 1988.02.02
CPAM

Proposal #2 for Memorial Gate, Ackland
Art Museum, University of North Carolina
at Chapel Hill, 1988
Graphite on paper
23 x 29 inches (58 x 74 cm)
Paley Studio Archive, GA 1988.02.01
CPAM

Fisher Rose Gate, 1989
Graphite on paper
paper: 14 x 17.25 inches (35.6 x 35.6 cm);
image: 6 x 6 inches (15.24 x 15.24 cm)
Paley Studio Archive, GA 1989.02.01
HP

Fisher Rose Gate Detail, 1989
Graphite on paper
paper: 14 x 17 inches (35.6 x 43.2 cm);
image: 5.75 x 3.5 inches (14.61 x 8.89 cm)
Paley Studio Archive, GA 1989.02.02
HP

Fisher Rose Gate (final), 1989
Graphite on paper
paper: 13.5 x 17 inches (34.3 x 43.2 cm);
image: 8 x 5.5 inches (20.32 x 13.97 cm)
Paley Studio Archive, GA 1989.03
HP

Fisher Pool Gate (first draft), 1989
Graphite on paper
paper: 14 x 17.25 inches (35.6 x 35.6 cm);
image: 9.75 x 5.75 inches (24.77 x 14.61 cm)
Paley Studio Archive, GA 1989.04.01
HP

Fisher Pool Gate (final), 1989
Graphite on paper
paper: 14 x 17.25 inches (35.6 x 35.6 cm);
image: 10 x 6 inches (25.40 x 15.24 cm)
Paley Studio Archive, GA 1989.05.01
HP

Proposal for a Plaza Sculpture,
Boston Massachusetts (*Portal*), 1989
Graphite on paper
29 x 23 inches (74 x 58 cm)
Paley Studio Archive, SCU 1989.07.01
CPAM

Portal Variations and Notes, 9/29/89
Pencil and ink on tag board
22.5 x 28.75 inches (57.2 x 73 cm)
Paley Studio Archive, PM 1989.07.03
CPAM

Linde Gate I, 1990
Ink on vellum
8.5 x 11 inches (21.6 x 27.9 cm)
Paley Studio Archive, GA 1990.01
CPAM

Linde Gate II, 1990
Ink on vellum
8.5 x 11 inches (21.6 x 27.9 cm)
Paley Studio Archive, GA 1990.02
CPAM

Linde Gate III, 1990
Ink on vellum
8.5 x 11 inches (21.6 x 27.9 cm)
Paley Studio Archive, GA 1990.03
CPAM

Linde Gate IV, 1990
Ink on vellum
8.5 x 11 inches (21.6 x 27.9 cm)
Paley Studio Archive, GA 1990.04
CPAM

Linde Gate V, 1990
Graphite on paper
23 x 29 inches (58.4 x 73.7 cm)
Paley Studio Archive, GA 1990.05
CPAM

Linde Gate (final), 1990
Graphite on paper
23 x 29 inches (58.4 x 73.7 cm)
Paley Studio Archive, GA 1990.06
CPAM

ASU Ceremonial Gate (Final Drawing), 1991
Graphite on paper
25 x 15 inches (63.5 x 38.1 cm)
Paley Studio Archive, GA 1991.01.01
CPAM

ASU Gate Proposal #2, 1991
Graphite on paper
25 x 15 inches (63.5 x 38.1 cm)
Paley Studio Archive, GA 1991.02.01
CPAM

ASU Gate Proposal #3, 1991
Graphite on paper
25 x 15 inches (63.5 x 38.1 cm)
Paley Studio Archive, GA 1991.03.01
CPAM

Study for Dayton Tabernacle Screen, 1993
Graphite on paper
22.5 x 28.5 inches (57.2 x 72.4 cm)
Paley Studio Archive, SCR 1993.01.03
CPAM

Proposal for Tabernacle Screen,
Temple Israel, Dayton, Ohio, 1993
Graphite on paper
22.5 x 28.5 inches (57.2 x 72.4 cm)
Paley Studio Archive, SCR 1993.01.02
CPAM

Proposal for "Passage," a Sculpture
for Asheville, North Carolina, 1993
Graphite on paper
paper: 14 x 11 inches (35.6 x 27.9 cm);
image: 11.5 x 6.5 inches (29.5 x 16.5 cm)
Signed and dated "Albert Paley, 3/5/93"
Paley Studio Archive, SCU 1993.01.01
CPAM

Study of San Francisco Elevator Door
Etching, 1994
Graphite on paper
29 x 23 inches (73.7 x 58.4 cm)
Paley Studio Archive, AO 1994.04.01
CPAM

Untitled (Proposal Drawing for
San Francisco), 1995
Graphite, ink, white-out on vellum
Paper: 36 x 19 inches (91.4 x 48.3 cm);
image: 30 x 10 inches (76.2 x 25.4 cm)
Paley Studio Archive, AO 1995.04.01
CPAM

Study for Desert Willow, 1998
Red pencil on paper
framed: 32.5 x 26.5 inches (82.6 x 67.3 cm)
Paley Studio Archive, SCU 1998.01
HP

Desert Willow Maquette, 1998
Formed and fabricated carbon steel, stainless
steel, and brass; natural rusted patina
25 x 26 x 11.25 inches (63.5 x 66 x 28.6 cm)
Paley Studio Archive, PM 1998.04
HP

Split Vision, 2000
Red pencil and graphite on paper
19 x 25.5 inches (48.3 x 64.8 cm)
Paley Studio Archive, SCR 1998.01.02
CPAM

Portal Gates (Naples gate patterns), 2000
Cardboard collage on paper
36 x 23.5 inches (91.4 x 59.6 cm)
Paley Studio Archive, PM 2000.01
CPAM

Paley Gates (Developmental Drawing), 2000
Graphite and red pencil on Mylar
24 x 20 inches (61 x 50.8 cm)
Paley Studio Archive, GA 2000.02.02
CPAM

Sentinel Model (initial model), 2001
Cardboard
6.75 x 17 inches (17.1 x 43.2 cm)
Paley Studio Archive, PM 2001.03
CPAM

Sentinel Model, 2001
Cardboard
34 x 29 inches (86.4 x 73.7 cm)
Paley Studio Archive, PM 2001.02
CPAM

Duncan Gates, 2002
Red pencil on paper
11 x 14 inches (27.9 x 35.5 cm)
Paley Studio Archive, GA 2002.02
HP

Reconfiguration (concept drawing), 2002
Black marker on rice paper
19 x 23 inches (48.3 x 58.4 cm)
Paley Studio Archive, GA 2006.01
HP

Reconfiguration, 2002
Assemblage: mild and stainless steel,
found objects, painted finish
Two archways:
25.6 x 28 x 7.3 feet (7.80 x 8.53 x 2.23 m) and
19 x 24.5 x 6.5 feet (5.79 x 7.47 x 1.98 m)
Architect: Wetherell Ericsson Leusink Architects,
Des Moines, Iowa
Commissioned by Howard F. and
Roberta Green Ahmanson and Hometown Perry
for Soumas Court, Perry, Iowa
Paley Studio Archive: GA 2006.01
Photo: Robert Reynolds

Proposal for Cleveland Botanical Garden,
Ohio (final Kohl Gate), 2003
Red pencil on transparent film
14.5 x 21.5 inches (36.83 x 54.61 cm);
framed: 27 x 33.5 inches (68.6 x 85.1 cm)
Paley Studio Archive, GA 2003.03.02
CPAM

Flora Study for the Cleveland Botanical
Garden, Ohio, 2003
Red pencil, black ink on transparent film
9.5 x 8.25 inches (24.1 x 20.9 cm)
Paley Studio Archive, GA 2003.03.03
CPAM

St. Louis Zoo Archway Model, 2004
Cardboard, wood, red pencil
1.5 x 11 feet (.46 x 3.35 m)
Paley Studio Archive, PM 2004.01
BAM

Double Cross (Constellation development
model), 2004
Formed and fabricated stainless steel finishes
with glass bead blast
37 x 46 x 9 inches (94 x 116.8 x 22.9 cm)
Signed: "Albert Paley 2004 2/6"
Paley Studio Archive, SF 2004.04
HP

Proposal Study for Memphis Portal
(a grid of 16 gates), 2004
Red pencil on paper
23 x 30.5 inches (9.1 x 12 cm)
Signed "Albert Paley 9.4.04
Paley Studio Archive, GA 2004.01
CPAM

Gate Proposal # 1 – Memphis Portal, 2004
Red pencil on paper
18 x 24 inches (45.7 x 60.9 cm)
Paley Studio Archive, GA 2004.01.02
CPAM

Gate Proposal # 2 – Memphis Portal, 2004
Red pencil on paper
18 x 24 inches (45.7 x 60.9 cm)
Paley Studio Archive, GA 2004.01.03
CPAM

Gate Proposal # 3 – Memphis Portal, 2004
Red pencil on paper
18 x 24 inches (45.7 x 60.9 cm)
Paley Studio Archive, GA 2004.01.04
CPAM

Gate Proposal # 4 – Memphis Portal, 2004
Red pencil on paper
18 x 24 inches (45.7 x 60.9 cm)
Paley Studio Archive, GA 2004.01.05
CPAM

Gate Proposal # 5 – Memphis Portal, 2004
Red pencil on paper
18 x 24 inches (45.7 x 60.9 cm)
Paley Studio Archive, GA 2004.01.06
CPAM

Cleveland Botanical Garden Gate Model
(Kohl Gate), 2005
Formed and fabricated A-36 steel with
copper with natural rust patina
36 x 136 x 8 inches (91.4 x 345.4 x 20.3 cm)
Signed: "Albert Paley 2005, EX-176" in base
Paley Studio Archive, SF 2006.24
CPAM

Iowa State University Project Proposal, 2005
Red pencil on paper
30.25 x 23 inches (76.84 x 58.42 cm)
Paley Studio Archive, SCU 2005.01.01
CPAM

Iowa State University Project Proposal, 2005
Red pencil on paper
38 x 24 inches (91.44 x 60.98 cm)
Paley Studio Archive, SCU 2005.01.02
CPAM

Iowa Sculpture Proposal – Morrill Hall, 2005
Foam core, cardboard, pen, paint, glue
25.5 x 48 x 24 inches (64.8 x 121.9 x 61 cm)
Paley Studio Archive, PM 2005.37
CPAM

Design Study, Good Shepherd Gate,
National Cathedral, 2005
Graphite and colored pencil on paper
13 x 9.5 inches (33.02 x 24.13 cm)
Paley Studio Archive, 2005.02.01
BAM

Study for Good Shepherd Gate
at the National Cathedral, 2005
Red pencil on paper
41 x 26.5 inches (104.1 x 67.3 cm)
Paley Studio Archive, 2005.02.02
BAM

MODELS / MAQUETTES
FOR ANIMALS ALWAYS

Unless otherwise noted, the following
models/maquettes are studies for
Animals Always (2006) and vary in height
and width from 3 to 6 feet (.91 x 1.8 m)

Model Elephant (for *Animals Always*), 2005
Cardboard and wood
41 x 56 x 24 inches (104.1 x 142.2 x 60.9 cm)
Paley Studio Archive, PM 2005.11
HP

Model Giraffe (for *Animals Always*), 2005
Cardboard and wood
75 x 39 x 20 inches (190.5 x 99 x 50.8 cm)
Paley Studio Archive, PM 2005.17
BAM

Model Bird, Ostrich (for *Animals Always*) 2005
Cardboard and wood
67 x 40 x 23 inches (170.1 x 101.6 x 58.4 cm)
Paley Studio Archive, PM 2005.19
BAM

Model Rhino (for *Animals Always*), 2005
Cardboard and wood
34 x 69 x 36 inches (86.3 x 175.2 x 91.4 cm)
Paley Studio Archive, PM 2005.20
BAM

Model Bird, Egret (for *Animals Always*), 2005
Cardboard and wood
37 x 53 x 37 inches (93.9 x 134.6 x 93.9 cm)
Paley Studio Archive, PM 2005.22
HP

Model Gorilla (for *Animals Always*), 2005
Cardboard and wood
30 x 33 x 13 inches (76.2 x 83.8 x 33 cm)
Paley Studio Archive, PM 2005.30
BAM

Model Wild Ox (for *Animals Always*), 2005
Cardboard and wood
23 x 51 x 29 inches (58.4 x 129.5 x 73.6 cm)
Paley Studio Archive, PM 2005.36
BAM

Elephant *(for Animals Always)*, 2006
Formed and fabricated mild steel, natural
rusted patina
35 x 9 x 32 inches (88.9 x 22.8 x 81.2 cm)
Paley Studio Archive, SF 2006.04
HP

Ostriches Pair *(for Animals Always)*, 2006
Formed and fabricated mild steel, natural
rusted patina
Paley Studio Archive, SF 2006.09
HP

Ox (for *Animals Always*), 2006
Formed and fabricated mild steel, natural
rusted patina
Paley Studio Archive, SF 2006.10
BAM

Shark and Angel Fish (for *Animals Always*), 2006
Formed and fabricated mild steel, natural
rusted patina
Paley Studio Archive, SF 2006.12
BAM

Alligator with Seahorses
(for Animals Always), 2006
Formed and fabricated mild steel, natural
rusted patina
Paley Studio Archive, SF 2006.13
BAM

Ostriches Pair *(for Animals Always)*, 2006
Formed and fabricated mild steel, natural
rusted patina
Paley Studio Archive, SF 2006.19
BAM

Ceremonial Archway (*Animals Always*), 2007
Formed and fabricated steel, natural rusted
patina with clear coat finish
20 feet long (6.10 m)
Signed "Albert Paley 2006" in base plate
Paley Studio Archive, PM 2005.02.b
BAM

Maquette for Passage, 2007
Formed and fabricated weathering steel
and stainless steel
49 x 21.5 x 17 inches (124.4 x 54.6 x 43.1 cm)
Signed "© Albert Paley 2007" in base
Paley Studio Archive, SF 2007.01
CPAM

Design Study for the Good Shepherd Gate
at the National Cathedral, 2007
Forged A-36 mild steel, brass, 24K gold plate
8.5 x 6 x 1 feet (2.59 x 1.83 x .30 cm)
Paley Studio Archive: AG 2007.01b
BAM

Duncan Gate Maquette, 2007
Formed and fabricated steel
18 x 40 inches (45.7 x 101.6 cm)
Paley Studio Archive, PM 2007.03
HP

Sentinel (presentation maquette), 2007
Formed and fabricated carbon steel with
natural patina
30 x 50 x 17 inches (76.2 x 127 x 43.1 cm)
Paley Studio Archive, PM 2007.03
CPAM

Portal (Variation on a plaza sculpture
for Boston, Massachusetts), 2007
Forged and fabricated stainless steel
with copper plating and natural patina
Stamped "© Albert Paley 2007"
47.5 x 21 x 15 inches (120.6 x 53.3 x 38.1 cm)
Paley Studio Archive, SF 2007.04

Transformation, 2007
Formed and fabricated stainless steel
Two sculptures: 15 x 15 x 2 feet
(4.57 x 4.57 x .61 m) and
9.6 x 10 x 2 feet (2.93 x 3.05 x .61 m)
In the Art on Campus Collection, University
Museums, Iowa State University, Ames, Iowa.
This project is funded in part by the Class of
1956, Iowa State University; Iowa Art in State
Buildings Project for Morrill Hall; University
Museums, Iowa State University; Rebecca Klemm;
Martha LeBuhn Allen; the National Endowment
for the Arts; and Ruth and Clayton Swenson.
CPAM

ALBERT PALEY | PORTALS & GATES
was produced in conjunction with the
exhibition of the same name on view from
August 20, 2007 through January 15, 2008
at the Christian Petersen Art Museum
and Brunnier Art Museum,
University Museums, Iowa State University;
and at Hometown Perry, Iowa.

© 2007
University Museums, Iowa State University
290 Scheman Building, Ames, Iowa 50011
515.294.3342
www.museums.iastate.edu

Albert Paley | Portals & Gates
By M. Jessica Rowe
First edition, 2007

Library of Congress Control Number:
2007905669
ISBN 10: 0-9798111-0-4
ISBN 13: 978-09798111-0-4

All titles of works of art are
supplied by Paley Studios, Ltd.

Published by University Museums,
Iowa State University, Ames, Iowa

Designed by Connie Wilson,
Des Moines, Iowa

Edited by Lea Rosson DeLong, Ph.D.,
Des Moines, Iowa

Photography by Bruce Miller, Rochester,
New York, unless otherwise indicated

4,000 copies were printed in China
by Landauer Corporation, Urbandale, Iowa

p. 132: Detail of **Portal**, 2005
Paley Studio Archive, SF 2005.02

p. 138: Detail of **Ceremonial Gates**, 1991
Paley Studio Archive, AG 1991.02

p. 143: **Study for the Smithson Crypt Gate**
(proposal study for the Smithsonian Institution,
Washington, D. C.), 1975
Graphite on paper
12.25 x 8.5 inches (31.1 x 21.6 cm)
Paley Studio Archive GA 1975.01.02

p. 144: Detail of **Rosecliff Portal**, 1994
Formed and fabricated steel, natural rusted patina
81 x 106 x 5 inches (205.7 x 269.2 x 12.7 cm)
Paley Studio Archive, AM 1994.01

UNIVERSITY MUSEUMS STAFF

LYNETTE L. POHLMAN
Director and Chief Curator

AMANDA HALL
Education Assistant and Security Officer

JANET MCMAHON
Administrative Specialist

SUE OLSON
Development Secretary

ELEANOR OSTENDORF
Curator of the Farm House Museum

ALLISON SHERIDAN
Collections Manager and Education Specialist

Christian Petersen Art Museum
UNIVERSITY MUSEUMS AFFILIATE

IOWA STATE UNIVERSITY
Brunnier Art Museum
UNIVERSITY MUSEUMS AFFILIATE

IOWA STATE UNIVERSITY
University Museums

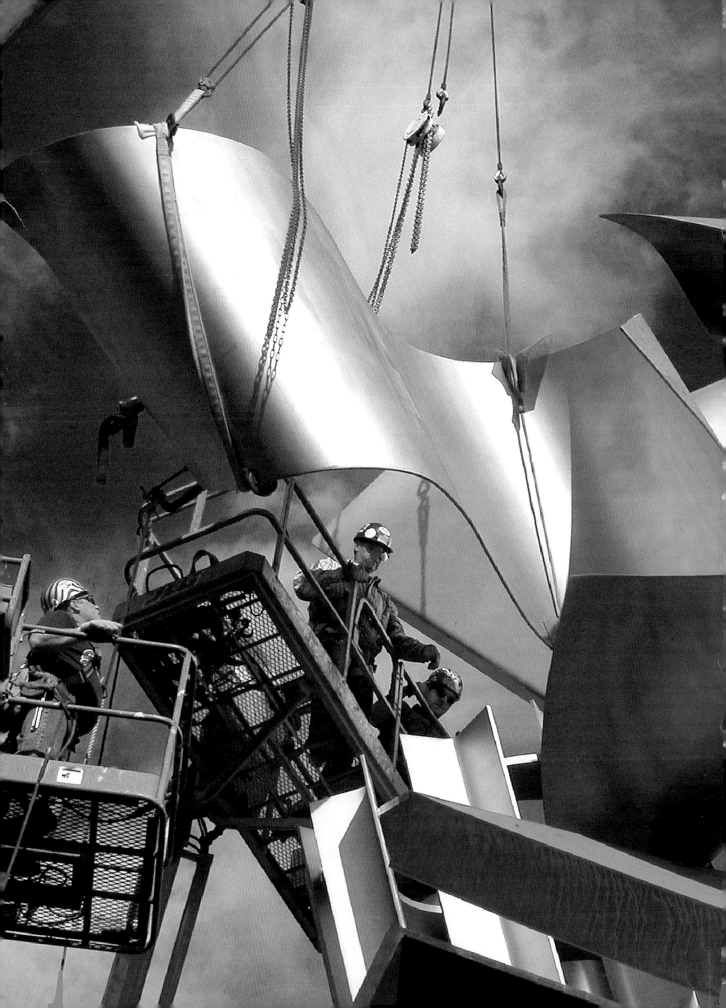